HOW TO TAKE BETTER POLAROID PICTURES

Weston Kemp

PRENTICE-HALL, INC., ENGLEWOOD CLIFFS, NEW JERSEY

Library of Congress Cataloging In Publication Data

Kemp, Weston D 1936-
 How to take better Polaroid pictures.

 (Modern photo guide) (A Spectrum book)
 1. Polaroid Land camera. 2. Photography—Handbooks,
manuals, etc. I. Title.
TR263.P6K43 771.3'1 75-17776
ISBN 0-13-434969-5
ISBN 0-13-434944-X pbk.

10 9 8 7 6 5 4 3 2 1

Printed in the United States of America

A Spectrum Book

Prentice-Hall International, Inc., *London*
Prentice-Hall of Australia Pty. Ltd., *Sydney*
Prentice-Hall of Canada, Ltd., *Toronto*
Prentice-Hall of India Private Limited, *New Delhi*
Prentice-Hall of Japan, Inc., *Tokyo*
Prentice-Hall of Southeast Asia (pte.) Ltd., *Singapore*

CONTENTS

INTRODUCTION

"A photograph fills different needs, at different times in life. There are ideas and understanding that people can never fully experience without photography. Photography can make a person pause in his rush through life, and in the process, enrich his life at that moment. This happens as you focus through the viewfinder. It's not merely the camera you are focusing, you are focusing yourself. Then when you touch the button—what is inside of you comes out. It's the most basic form of creativity. Part of you is now permanent. Photography can teach people to look, to feel, to remember, in a way they didn't know they could."—Dr. Edwin Land, founder of the Polaroid Corporation.

This book is intended as a guide to introduce you to the world of "instant photography" and to make you more aware of the great array of imaging opportunities you encounter daily. The scores of photographs on these pages have been selected as a stimulus to jog your vision and imagination.

With the introduction of the remarkable SX-70 Land camera, Dr. Land and his multi-talented research team have reached the long sought goal of One-Step Photography. They, in photography's one hundred and thirty-third year, have successfully developed a system with which: You Press the Button—and the Camera Does the Rest.

Dr. Land suggests, "There can be as much variety and delight in the work of thousands of people, as much uniqueness, person by person, as we have come to expect in the past only from the greatest names in the history of art."

ACKNOWLEDGEMENTS

Above all, a very special note of appreciation to the photographer/artists represented for their cooperation which made possible the publication of this work.

For sustained encouragement, support, and critical attention to illustrations, I am indebted and grateful to Lynne Austin Bentley-Kemp, my very understanding and sensitive wife.

Greatly appreciated was the editorial assistance of Marlene Ledbetter who was responsible for transcribing dictation into the written word. Her constant attention to style, grammatical construction, and presentation of material was invaluable.

I particularly extend appreciation to Jon Holmes, Bill Field, and Inge Reethof at Polaroid . . . and, most certainly, to Dr. Edwin Land for making it all possible.

For their interest and ready assistance, I am indebted to Michael Hunter, Hank Kennedy, Marvin Warshaw, Marjorie Streeter and Shirley Covington at Prentice-Hall.

Weston D. Kemp.

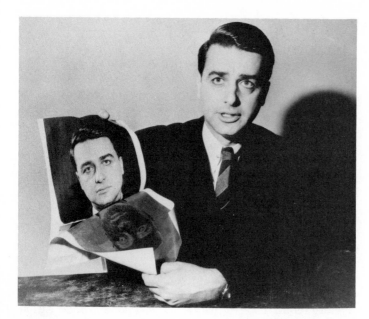

Dr. Edwin Land exhibiting an early "picture-in-a-minute" at a 1947 press conference to announce the successful development of the Polaroid photography system.

This collection of laboratory vials is representative of the hundreds of specially synthesized chemical substances used in the development of an "Instant-Color" process now known as Polacolor Land Film.

EVOLUTION OF POLAROID LAND PHOTOGRAPHY

THE EVOLUTION OF "INSTANT PICTURES"

About 30 years ago, a young father unlimbered a camera to photograph some important moments in the childhood of his small daughters. Frustrated at not knowing how the photographs were going to come out and impatient over the delay in getting the rolls of film developed and printed, this young father resolved that he would find a way to build a camera and film system that would product finished prints instantly.

The man was Edwin Land who, as an undergraduate physics major at Harvard College, had astonished the science world by discovering a way to make a synthetic polarizer, a device which reduces glare by absorbing reflected light. In 1937, Land, while still a student, formed the Polaroid Corporation to commercially produce polarizers. Land and his small group of scientists and technicians produced the great quantity of polarizing materials essential to the military and scientific requirements posed by the second world war.

It was during the early forties that Land hit upon the idea of instant pictures. With the ending of World War II and the winding down of wartime demand for polarizers, Land and his associates applied themselves to the challenge of inventing a completely new system of photography. This historic effort resulted in the introduction of the first Polaroid Land camera in 1948.

Understandably, the "picture in a minute" camera had its share of skeptics. Established camera and film manufacturers virtually ignored Land's accomplishments. A national news magazine reported on it in tongue-in-cheek style.

The first camera was bulky and awkward. The prints exhibited a brownish tone (sepia) unlike the more neutral black and white tones the public was accustomed to seeing. Land and his dedicated group of researchers, working in a drafty old factory building in Cambridge, Mass., had developed a camera system that would produce snapshot-size positive prints one minute after the shutter was clicked. To accomplish this photographic milestone, they invented a processing mechanism that would fit inside a relatively standard camera design and a new film concept incorporating the processing chemistry, the print paper, and the light sensitive negative material—all in one package.

Today, all skepticism about the potential of Polaroid Land photography is long dead. The name Polaroid is known world-

wide. The Russians have for some time been marketing a camera called *The Moment,* a surprisingly similar replica of an early Polaroid Land camera. Today countless millions of Polaroid Land cameras are in use, photographing everything from a child's first moments with a new puppy to cellular growth through an electron microscope.

The activities of that small band of creative scientists, working under Dr. Land's leadership, have made worldwide scientific headlines through the years: first the concept of a "picture in a minute" camera, then color photography in 50 seconds, followed by an efficient flat pack film, and now a pocket single-lens reflex camera producing color photographs which develop immediately outside the camera. On the horizon are instant home movies (already demonstrated to stockholders), instant color slides, smaller more inexpensive personal cameras, and a variety of sophisticated imaging systems for science and industry.

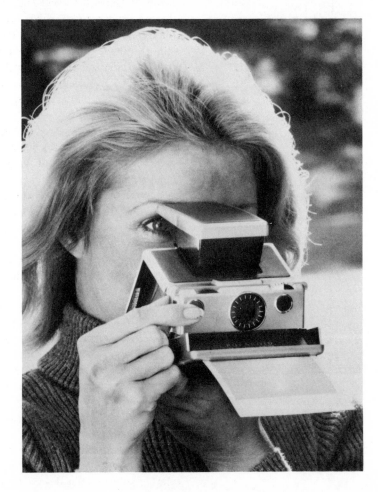

1 DIRECTORY OF LAND FILMS

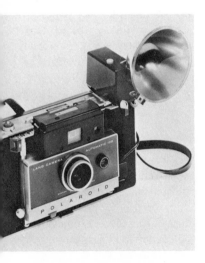

The Model 100 Polaroid Land Camera

This camera, introduced in 1963, made instant photography considerably easier. Loading was simpler and more rapid with the new pack films. The pictures developed outside the camera, allowing fast picture sequences not previously possible. The advanced electronic exposure mechanism gave well-exposed pictures over a wide range of lighting conditions.

There is a bewildering array of Polaroid Land cameras in all shapes and sizes available in today's photographic marketplaces. They range in price from $10 dollars to more than $2,000 dollars. All are literally "superboxes". Regardless of how expensive or complex a camera may be, though, all have the same basic parts:

* a light-tight box which keeps unwanted light from exposing the film and acts as a support for the other parts of the camera.
* a lens that collects the light reflected from a subject and focuses an image of that subject on the film.
* the lens opening, usually referred to as the diaphragm or aperture, which controls the intensity of light reaching the film while the shutter is open.
* a shutter which keeps light out of the camera except during that brief moment when a picture is being taken. At that time it acts as a valve to control how long light is allowed to expose the film.
* a shutter release which opens and closes the shutter.
* a film advance and processing mechanism which advances the film for the next exposure and initiates the developing of the picture.
* a viewfinder which allows the photographer to frame his subject accurately.
* a flash socket. Most Polaroid cameras have a socket for flash cube, flash bulb, or flashbulb holder.

For all practical purposes, Polaroid cameras can be placed in one of the following categories:

* Rollfilm cameras
* Pack-film cameras
* SX-70 system cameras

The Polaroid Land CU-5 Camera

This special-purpose camera is designed for close-up photography with a wide range of applications in medical, industrial, and scientific laboratories.

Sub-categories would include:

- Adjustable cameras
- Automatic-exposure cameras
- Fixed-exposure cameras
- Special-purpose cameras.

THE ROLLFILM POLAROID CAMERAS

Dating from the first Polaroid Land camera, the rollfilm models are designed to accept a special double roll of negative film or paper and a specially-coated paper or transparent film to receive the positive image which is transferred from the negative when processed. The two rolls are drawn together when the picture is pulled between rollers or spreader bars to initiate the development cycle. The rollfilm polaroid cameras are necessarily heavier and bulkier than the other types of Land cameras. This version of the Land cameras include Models 95, 150, 800, 80, J-66, 900, 110, and the Swinger among others.

THE PACK-FILM CAMERAS

The first pack-film camera (Model 100) was introduced in 1962 It was lighter and more compact than previous Land cameras and featured a remarkably accurate and reliable automatic exposure system. The film-pack contained film and positive print paper for making eight 3 X 3¾ prints. The pack-film cameras enjoyed an immediate success. They were much easier to load, no trouble to carry and offered a new convenience for instant photography. The new automatic exposure system could even control exposures for flash pictures; long a frustrating and complicated technique for most family snapshooters.

SX-70 SYSTEM CAMERAS

The totally new system of instant photography was inaugurated with the marketing of the SX-70 camera in late 1972. After nearly 150 years of evolution and progress in photography, the Polaroid Corporation achieved the dream of an instrument with which "You Press the Button and the Camera Does the Rest." With the SX-70, you compose and focus the picture, then upon pressing the shutter button, the camera electronically controls the exposure and immediately commences the processing cycle. The picture is automatically ejected from the camera and slowly reveals an increasingly beautiful image as it develops before your eyes in even the brightest sunlight. No waste picture tabs, no

gooey negatives to dispose of, and no awkward picture-coating to do.

AUTOMATIC-EXPOSURE CAMERAS

Polaroid's automatic cameras have complex electronic circuits which measure the light which will enter the lens when an exposure is made. The circuits are activated by the shutter release and instantaneously control the opening and closing of the shutter and aperture. The cameras have provisions for adjusting the lightness or darkness of the prints to the photographer's personal taste. Automatic cameras permit almost anyone to make well-exposed photographs every time. An automatic-exposure Land camera is the best choice for the casual family snapshooter who insists on no-fuss picture-making.

ADJUSTABLE-EXPOSURE CAMERAS

Land cameras such as the model 110 or 180 carry traditional shutters and aperture controls. Used with exposure meters, these cameras permit the photographer to select the diaphragm opening and shutter speed combinations appropriate under various lighting conditions and picture situations. With these controls, the photographer can use a high shutter speed to stop fast action or select a tiny diaphragm opening to yield maximum sharpness from near to far. The lightness of the photograph is controlled by adjusting the diaphragm and shutter speed settings. Some of the less expensive Land cameras have an electric eye coupled with the aperture and/or the shutter. Exposure is controlled with these cameras by observing an exposure metering signal system in the viewfinder. To set the correct exposure, words or arrows are adjusted according to directions supplied with the camera. For example; with the Polaroid Swinger Land cameras, the viewfinder displays a small YES inscribed on a checkerboard. Squeezing and turning a red button on the front of the camera varies the amount of light to pass through the lens to produce a clear YES. A clear YES indicates the lens aperture is set for correct exposure.

SPECIAL-PURPOSE CAMERAS

Special-purpose Land cameras include the BIG SHOT, for close-up portraits; the Polaroid CU-5 Land camera, for ultra-closeups in the lab, office or field; and the Polaroid MP-4 Multipurpose Land Camera, for copying, photomacrography, and projection printing. These special-purpose Land Cameras are designed for specific picture-making applications. They are specially noted for simplicity of operation: a valuable plus in many industrial applications.

The Polaroid SX-70 Land Camera

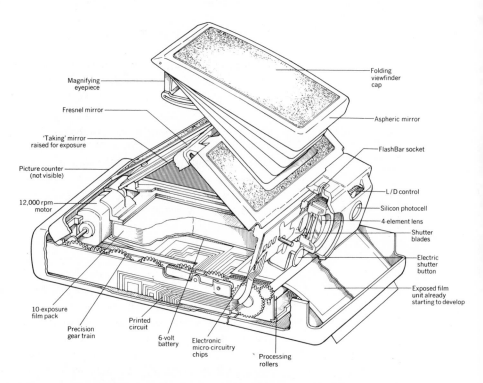

Magnifying eyepiece

Folding viewfinder cap

Fresnel mirror

Aspheric mirror

'Taking' mirror raised for exposure

FlashBar socket

Picture counter (not visible)

L/D control

12,000 rpm motor

Silicon photocell

4-element lens

Shutter blades

Electric shutter button

Exposed film unit already starting to develop

10-exposure film pack

Precision gear train

Printed circuit

6-volt battery

Electronic micro-circuitry chips

Processing rollers

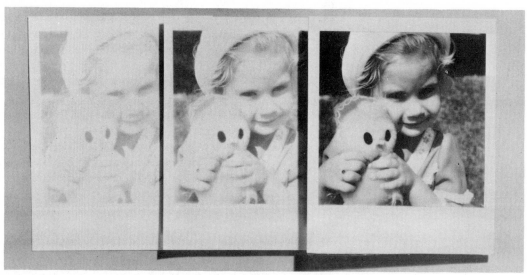

These photographs demonstrate the automatic development of an SX-70 photograph. Development takes about ten minutes but the colors do become visibly richer after several hours. There's no need to "time" the development of SX-70 pictures.

The Polaroid SX-70 Land camera is a fully automated, well-designed, pocket-sized camera. It makes pictures that develop outside the camera in a totally different way. The camera can be carried comfortably in a jacket pocket or a ladies handbag. It weighs only 24 ounces.

Dr. Land, the president and director of research at Polaroid, long had nourished a dream of a camera that would produce color photographs immediately, without the fuss and aggravation of having to wait days to enjoy the pictures. Art Kane once expressed the thought, "I wish there were a thing that I could put in my eye, just blink, twist my ear, and pull it [a photograph] out of my mouth." The SX-70 camera is a fantasy realized.

Collapsed, the SX-70 Land camera resembles an elegant leather-covered case. When opened for picture making, it looks like no camera you've ever seen. This case contains a fully automated, electronically controlled, light-weight, and elegantly styled single-lens reflex camera which can be easily pocketed when folded.

The SX-70 Land camera uses a silicone photo cell to measure incoming light linked with an electronic shutter to calculate exposures ranging from 1/200 second to more than 20 seconds. This allows the camera to function in various light levels with considerable latitude. If you're not careful, you may find yourself inadvertently trying to handhold the camera for what turned out to be a lengthy time exposure. The compactness of the camera dictated a radically new optical system which took years of research. Two and a half years of full-time computer work were required to determine the proper curve of the concave mirror in the viewing system. The SX-70 Land camera is the only camera in which the optical image is bounced from a mirror before striking the film.

This camera is equipped with a four-element 117 mm. f/8 lens, corrected for chromatic and spherical aberrations, coma, astigmatism, and field curvature. All this packed into less than a half inch of optics!

Focusing is by a movable front element traveling less than one-quarter inch for an entire focus range of 10 inches to infinity.

The collection of miniaturized solid-state circuits cleverly integrated into SX-70's interior (the equivalent of more than 200 transistors) control a complex and precise automated exposure and film transport system.

Picture making consists only of focusing and pushing the shutter button—the camera and film do the rest. For flash pictures, General Electric created the Flashbar, a specially designed, self-contained flashbulb unit with an array of five bulbs alongside one another with another five on the opposite side. The Flashbar is inserted into its socket on the camera lens. The camera's electric

The SX-70 Filter and Closeup Kit

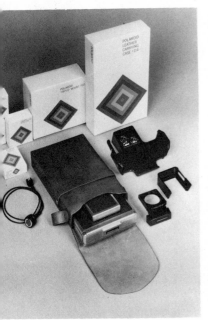

The unique optical system
of the Polaroid SX-70 Land Camera

The Polaroid SX-70 Land camera is a unique folding single
lens reflex which allows the photographer to view the scene
through the lens of the camera before taking the picture,
but eliminates the heavy, bulky pentaprism found in
conventional SLR cameras. This revolutionary folding
optical system—composed of several mirrors and a magnify-
ing eyepiece, folds to a thickness of one inch for convenient
carrying of the SX-70 camera in a pocket or purse.

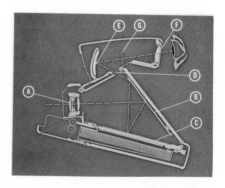

Light enters the camera through the four-element glass lens
(A), strikes a permanent mirror (B), and reflects down onto
a special Fresnel mirror (C), which bundles it into a beam
and projects it out of the camera through a small exit hole
(D). The light beam strikes an aspheric mirror (E) just
below its center-line, and passes through the magnifying
aspheric eyepiece (F) to the viewer's eye. The image forms
in a plane (G) just above the exit hole, and the light comes
to a focus just behind the pupil of the eye. The scene is
presented to the viewer right-side-up and correctly posi-
tioned left-to-right.

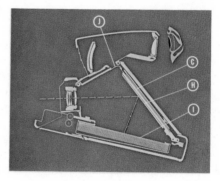

When the user touches the shutter button to make an
exposure, the Fresnel mirror (C) rises up against the back of
the camera, bringing a trapezoidal "taking" mirror (H) into
the light path. This mirror reverses the image into the
correct left-to-right orientation as it reflects it downward
onto the now uncovered negative (I) in the film pack. A
small rubber flap (J) attached to the pivoting carrier which
holds the Fresnel mirror and "taking" mirror seals the exit
hole at the top of the camera to prevent a light leak during
exposure.

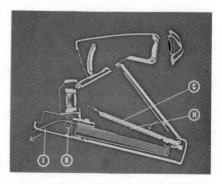

After exposure, the film unit (I) is automatically driven
through two small rollers (K) which rupture a pod of
reagent and spread it between the film unit's positive and
negative sheets to begin the development process. Simulta-
neously, the pivoting mirror assembly with the Fresnel
mirror (C) on one surface and the trapezoidal taking mirror
(H) on the other drops down to cover the film pack and
return the camera to the viewing mode for the next picture.

The Polaroid SX-70 Model 2 Land Camera is functionally identical to the original SX-70 camera, incorporating all of the same electronic, optical, and mechanical innovations. The SX-70 Model 2 camera is capable of utilizing all the accessories made for the deluxe SX-70. The Model 2 sells for about thirty dollars less.

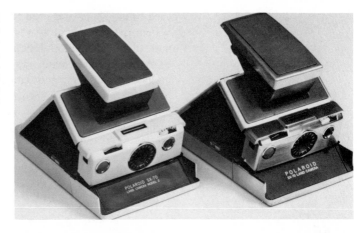

eye is automatically disconnected and the f/stop is controlled by the focusing mechanism. The Flashbar can be removed when it's not needed. When repositioned the next time, an electronic circuit seeks out the next available bulb.

The new SX-70 color film represents an intensive collection of unorthodox approaches. The new film is an integral assembly of 15 microscopically thin layers, some no thicker than a wavelength of light, operating with new chemistry incorporating metallized dyes specially synthesized for Polaroid.

A special battery had to be designed to fit into the film pack and power the complex mechanisms. Since a battery-powered camera operates best with a fresh battery, Polaroid engineers cleverly designed a system which contains a battery in the film pack. Everytime a fresh film-pack is inserted in the camera, it carries its own fresh supply of power. The filmpack is also designed to make it impossible to load the camera incorrectly. The filmpack is slightly wedge-shaped and only goes in one way.

As soon as the camera is loaded, strange noises signal the ejection of the filmpack cover sheet which can be used to order additional prints from Polaroid. After an exposure is made, a turquoise colored picture unit is expelled from the camera. At first the picture area is defined by uniform green coloration. The initial stages of image formation quickly begin. Details begin to emerge. A fair resemblance of the final picture can be observed after two or three minutes development. Development appears to be complete in about 10 minutes, although it's apparent that the image does subtly improve with age. The final print is a vivid, well-saturated color image on a hard, dry sheet of plastic-coated paper. The SX-70 Land film is as well an ecologist's delight. It was designed to be garbage-free.

This camera and film system allows taking picture sequences without the need to stop and carefully time the development of

each print. There's no need for timing. This instant photography system is the result of 15 years of research with an investment of more than 250 million dollars. The system enables the camera to be employed with greater ease and convenience than any previous method of producing photographs. It will finally permit people to be totally involved in photography, much as they are involved in relationships with others, without a conscious awareness of the technologies on which this photography depends.

Photograph by Inge Reethof

The SX-70 portfolio

Photograph by Inge Reethof

Photograph by Bill Buckley

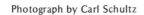

Photograph by Carl Schultz

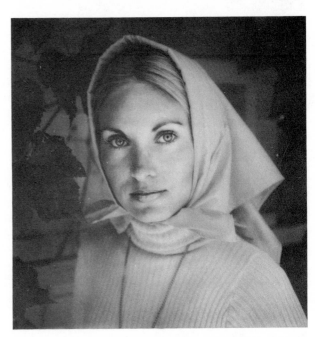

Polaroid rollfilm cameras

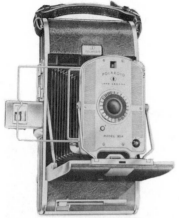

Model 95A Land Camera

An improved version of the first "Instant Photography" camera, the Model 95A has lost none of its appeal for vintage camera enthusiasts. Polaroid continues to manufacture black/white and color film for this and all other early models.

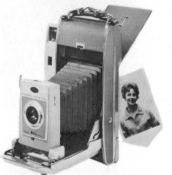

Model 850 Land Camera

The Model 850 and a sister model; the 900, are very similar. The main difference between them is that the 850 has separate rangefinder and viewfinder windows; on the 900 they are combined. These two models are notable as the first automatic high quality cameras from Polaroid. The automatic shutter speeds are from 1/12 to 1/900 second with an aperture range of f/9 to f/82.

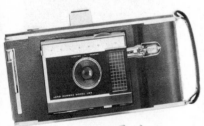

Model J-66 Land Camera

This model is among the simplest of the roll film Polaroid cameras to operate. The J-66 and it's little sister; the J-33, are fully automatic cameras. The camera is set for ordinary scenes or for portraits. A lighten-darken control permits fine adjustment for the exposure and a low light indicator signals the need for flash.

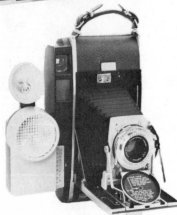

Model 110B Land Camera

Here's a sophisticated, non-automatic model which, along with its predecessors; 110 and 110A, offers a high quality lense and a wide range of f/stops and shutter speeds. The shutter has provisions for an optional EV system with a locking lever that joins lens and shutter speed combinations. These cameras have a self-timer and flash synchronization for bulbs, wink-light, and electronic flash.

Polaroid packfilm cameras

Model 103 Land Camera

This camera is a lower priced version of the once top-of-the-line Model 100. The 103 is a plastic bodied camera with an automatic shutter capable of exposures to one second. The camera uses the same accessories as the more expensive models in the 100 series. This series of cameras were the first designed for the new pack films. They are considered "obsolete" by many photo dealers and are often available at bargain prices.

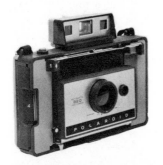

Model 320 Land Camera

This is an inexpensive example of the evolution of the pack film cameras. The 320 is a rangefiner focusing, eye-level viewing camera with an automatic shutter. The lens is a two-element 114mm, f/8.8 . The camera can be used with an optional flash unit with provisions for direct or bounced illumination.

Model 240 Land Camera

This camera, one of the 200 series, can automatically time exposures for as long as ten seconds for black and white and for five seconds with color film. The 240 has a metal body with a triplet lens for which filters and close-up lenses may be found. Focusing is accomplished by right and left finger levers which work against each other and are coupled to the eye-level rangefiner. Originally priced at $130, these cameras are a good buy at many photo stores with a stock of used cameras.

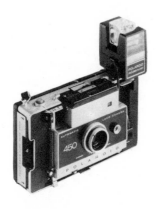

Model 450 Land Camera

The 450 is the top-of-the-line model in the current 400 series of automatic pack film cameras. It features a 3-element f/8.8, 114mm, color corrected lens in a transistorized electronic shutter. It has a built-in electronic processing timer which is triggered when the picture is pulled from the camera. The camera is made of metal and is the only model in the series with a tripod socket. The Model 490 Focused Flash unit provides a flash range of 3 1/2 to 10 feet.

The Swinger and Bigshot

THE POLAROID SWINGER LAND CAMERAS

The Polaroid Swingers are inexpensive personal cameras for instant snapshots under normal light conditions. They have fixed-focus, single element, meniscus lenses. The exposure control system uses a simple photometer. This instrument enables the brightness of one light source to be determined by comparing it with the known brightness of another light source. When the camera is aimed at a daylight scene, light passes through the small window located above the lens, through a diffuser and then through a checkerboard. At the same time, a tiny bulb lights up when the red knob is squeezed, reflecting light of the checkerboard squares. To adjust exposure, the red knob is squeezed and twisted until a clear YES appears on the checkerboard. At the same time, the aperture blades behind the lens are set so that the film will be properly exposed. The YES exposure system is designed only for daylight pictures.

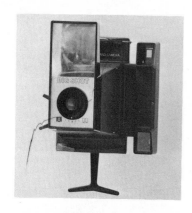

The "BIG SHOT" portrait camera for amateurs makes only one kind of picture—a color head-and-shoulders portrait. The Polariod Portrait Land Camera was designed for the amateur who would like to make studio quality portraits of people or pets, or close-up pictures of objects, without the usual concern for complexities of lighting or the technicalities of close-up picture making.

Big Shot has few moving parts other than the shutter release lever and shutter blade. The lens is fixed at f/25, the shutter is fixed at 1/60th of a second, and the camera focus is fixed for about 38 inches. Big Shot is designed for use only with Polaroid Polacolor Land film (Type 108) in combination with a Magicube or other batteryless flashcube. Flash is used for every picture. There are no exposure settings.

To make a picture with Big Shot, stand about four feet from your subject and look through the fixed-distance double-image rangefinder/viewfinder, moving backward or forward slightly until the two images in the bright center of the rangefinder merge into one clear image. This will occur when the subject is about 38 inches from the camera lens, Once in focus, you squeeze the shutter lever to make the flash exposure and pull the film tab from the camera to start development. The camera has a 60-second mechanical development timer to signal when the picture is ready.

The flashcube rotates automatically when the shutter lever is released. After all four bulbs have been fired, the shutter lever locks until a new flashcube is inserted.

The color pack cameras

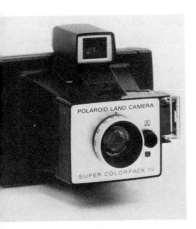

The inexpensive and durable Colorpack cameras are a popular choice for personal snapshots in daylight and with a built-in flashCube socket, are always ready for flash pictures. These cameras will make color photographs using Type 108 Polacolor film and Black and white photographs with Type 107 and Type 105 P/N. Various models feature focusing with either a simple to use Distance Finder or a clever Color Spot in the viewfinder which you match up with the subjects face.

These cameras use both regular and Hi-Power flashcubes. The cube automatically rotates to a new bulb after each picture. The flash range with regular flashcubes is 4-8 feet, with Hi-Power flashcubes from 4-12 feet. The development timer on the camera is adjustable for up to 120 seconds.

For cold weather pictures, a Cold-Clip is carried in a pair of slots on the back of the camera. The Cold-Clip must be pre-warmed in an inside pocket or between your arm and body before use. Immediately after pulling the developing print from the camera, it should be placed in the Clip which is then placed between your arm and body for the recommended processing time. The print is then separated.

The Colorpack cameras are a good choice for less experienced picture makers. Polaroid is always ready to help if you have any problems with the camera or film. If you do have a problem, call Polaroid Customer Service toll-free at 800-225-1384 from anywhere in the U.S.A. except Massachusetts. From within Massachusetts, and from Canada, you may call collect at (617) 864-4568.

Caring for your Polaroid camera

The proper care and maintenance of your photographic equipment are just as important as subject matter and correct exposure in striving for good photographic results. Your camera is a fine precision instrument capable of providing years of reliable service without extensive maintenance. However, there are some simple but essential things you can do to keep your camera at top operating condition.

One of your camera's greatest enemies is dirt—dirt can give your pictures a hazy appearance, jam your shutter, or spot your prints.

CAMERA LENSES

Dirt or fingerprints on your lens cause hazy pictures. If your camera has a lens cap, put it over the lens to protect against dirt and scratches. Clean your lens according to the instructions in your camera manual. First, carefully blow away any grit or dust, or brush it away with a camel's hair brush; then gently wipe the surface of the lens with a clean, soft, lint-free material such as *lens cleaning paper.* If moisture is needed, either breathe on the lens before wiping or moisten the lens cleaning paper with a *drop* of clean water or special *lens cleaner*, and wipe the lens. Clean

These photographs show the relative loss in picture quality caused by a dirty lens. It takes only a moment to clean a lens with a photo-quality lens tissue or old, but clean, handkerchief.

both the front and back of the lens (if the back of the lens is accessible through the inside of the camera). On cameras with interchangeable lenses, remove the lens to clean both sides. Don't try to take apart the lens itself. Caution: *Never* use a treated cleaning material that you would normally use on eyeglasses for cleaning lenses on photographic equipment. The chemicals contained in these cleaning materials can remove the special coating on photographic lenses.

Clean the lens after all the other parts of the camera have been cleaned. This prevents dust from settling on the lens while you are cleaning the rest of the camera. Or, if your camera has a lens cap, put it on the lens when you clean the camera.

You can use the above methods to clean your filters and viewfinder lenses, too. When dirty, these also transmit poor images.

CAMERA BODY

Dust and dirt inside your camera can cause spots on your pictures and can jam the shutter apparatus as well. Use a rubber syringe to blow dirt from the inside of the camera, or clean it with a soft brush. Always inspect your camera before inserting new film. Be sure to clean in and around the film cavities and rollers.

There is less chance of dust and dirt on the outside of the camera body affecting the internal mechanisms, but it is a good idea to clean there also. Fine dust can work itself into the camera from the outside.

LUBRICATION

As a rule of thumb, don't lubricate your camera. Most cameras are lubricated with a special "dry" lubricant by the manufacturer and usually need no further lubrication. Don't lubricate your camera unless the directions packaged with your camera tell you to. Lubrication on your equipment might collect dust, which can cause sluggish operation and possibly stoppage.

REPAIRS

If your camera is not operating properly, consult your instruction manual. If your camera's problem isn't covered there, take the camera to your photo dealer or to a Polaroid camera repair service center.

Some people tend to ignore poor operation by any part of their camera, hoping that nothing is seriously wrong or that the problem will cure itself if given time. The problem usually gets worse and more extensive repair will become necessary.

2 POLAROID LAND FILMS

Negative image of photograph made with Type 105 Land film

Positive print made with above negative

A Polaroid photograph requires four basic elements to produce an image:

* light
* a material that's sensitive to light—film
* a device to control the exposure of light to film—a camera
* chemicals and a mechanism to process the film

How is an image captured on film? There are two basic parts to film: the support and the light sensitive emulsion. The support is needed to hold the important upper layer. The emulsion is a layer of very pure gelatin in which is suspended chemicals and silver salts. It's thinner than a human hair split in 10 parts.

Contemporary Polaroid Land film operates on the same basic principle as the materials used by the early explorers in photography. The light coming through the lens is recorded on microscopic crystals of a silver halide carried in a transparent gelatin (the emulsion). The emulsion is thinly spread on a film or paper support. When processed, the resulting image is referred to as the negative.

A negative is, in its simplest terms, a reverse of the scene photographed. Where much light has struck the film, more dark metallic silver atoms were formed. The darkest areas in the negative correspond to the lightest areas in the original scene.

Manufacturers describe a film by its sensitivity, or speed, which is indicated by its ASA rating, a numerical system formulated by the United States of America Standards Institute (formerly the American Standards Association). A high ASA number means that you can get your picture with less illumination, or, alternatively, you can use a higher shutter speed to stop action. Most films are designated slow, medium, or fast. A slow film would be in the ASA 20 to 50 range, medium film in the ASA 100 to 200 range, fast film in the ASA 400 to 3000 range.

Polaroid's palette of films

PACK FILMS

Film Type	Format	Picture Obtained	Picture Size	Approx. Speed (ASA Equiv.)	Devel. Time At 75 F (24 C)
107	8-exposure pack	Black and white print	3¼ x 4¼ in.	3000	15 sec.
105 P/N	8-exposure pack	Black and white print and negative	3¼ x 4¼ in.	75	20 sec.
108	8-exposure pack	Color print	3¼ X 4¼ in.	75	60 sec.

ROLL FILMS

Film Type	Format	Picture Obtained	Picture Size	Approx. Speed (ASA Equiv.)	Devel. Time At 75 F (24 C)
42	8-exposure roll	Black and white print	3¼ x 4¼ in.	200	15 sec.
47	8-exposure roll	Black and white print	3¼ x 4¼ in.	3000	15 sec.
48	6-exposure roll	Color print	3¼ x 4¼ in.	75	60 sec.
46-L	8-exposure roll	Continuous-tone black and white transparency	2½ x 3¼ in.	800	2 min.
146-L	8-exposure roll	High-contrast black and white transparency	2½ x 3¼ in.	100	30 sec.
410 trace recording	6-exposure roll	High-contrast black and white print	3¼ x 4¼ in.	10,000	15 sec.

To facilitate rapid sequence recording, Type 410 film may be advanced after 2 seconds and prints developed 13 seconds outside the camera.

SHEET FILMS

Film Type	Format	Picture Obtained	Picture Size	Approx. Speed (ASA Equiv.)	Devel. Time At 75 F (24 C)
51	Single-exposure packet	High-contrast black and white print	4 x 5 in.	200	15 sec.
52		Black and white print	4 x 5 in.	400	15 sec.
55P/N	(20 packets to box except Type 58— 10 packets)	Black and white print and a permanent negative	4 x 5 in.	50	20 sec.
57		Black and white print	4 x 5 in.	3000	15 sec.
58		Color print	4 x 5 in.	75	60 sec.

For years there has been a truism in photography: the faster the film, the grainer it is. Most Polaroid films are exceptions to this rule. Even the ultra-fast ASA 3000 Polaroid Land film is remarkable both for its great speed and for the fact that this speed is achieved without sacrificing grain quality. Although ordinary films generally suffer in grain as they increase in speed, the Polaroid films do not.

Polaroid Land film employs a diffusion transfer process in which the silver from the negative physically travels across a very narrow gap to the positive paper print. This gap is so small that there is little random clumping of silver which would cause graininess and loss of detail.

Since Polaroid Land picture rolls and packets carry their own developers, they are naturally more sensitive to aging and temperature than ordinary films. You should make certain that the film you buy and use is reasonably fresh and not outdated. You'll sometimes find outdated films offered for sale at bargain prices. Each Polaroid film is stamped with an expiration date; for serious photography you should avoid using film that is past the expiration date. Old film can be useful for experimenting and trying out ideas.

Most of the Polaroid black and white films require only a 15 second development, and the color films call for a 50 second development. This can vary, particularly when you are working in cold temperatures. Remember to check the instructions that come with each film to see how the processing times may vary. This is particularly important with Polacolor which is very sensitive to temperature changes.

Developing times can be lengthened with most films to give you increased contrast.

Polaroid Land camera users can now choose from a wide variety of films. Among your choices are roll, pack, and sheet films which produce a finished color picture in 60 seconds with a film speed of ASA 75; an ultra-fast black and white film for general photography with a speed of 3000 ASA, yielding a finished print in 15 seconds; more specialized films which instantly produce images in X-ray units; or a film which produces high contrast black and white images for graphic arts applications. Polaroid Land Type 410 film is designed for oscilloscope trace recording; it has the incredibly high film speed of ASA 10,000. There are Polaroid films that yield both a print and a fine-grained, well-gradated negative in just 20 seconds, Polaroid Land Type 55 P/N and Type 105 P/N. It's been available only in 4 X 5, single exposure packets that fit a special Polaroid Land 4 X 5 film holder for use in professional press and view cameras and the Polaroid MP-4 Multi-purpose Industrial view camera.

Specifications for each of the currently marketed Polaroid films and examples of their picture-making potential are presented on these pages.

Many Polaroid prints (with the exception of Polacolor and Type 20) should be coated as soon as possible after removal from the camera. A properly coated print will last as long as any conventional picture.

Place the print to be coated on a clean, flat surface such as the film box. Clean conditions are important because if a particle of dirt gets into your coater it can scratch the print leaving streaks across it which do not come out. Be especially careful when working under windy and dusty conditions. The appearance of your prints can be marred if dust or dirt gets on the surface before the coating can dry. Use only a fresh coater that is moist so that the liquid spreads smoothly and evenly over the print. A dried-out coater will not spread the solution properly and may cause streaks that will show up in the print a few months later.

Proper coating protects your prints and insures a long life for them. If you're not satisfied with the way your prints were coated, it is possible to remove the original coating with a piece of cotton dipped in a mild solution of water and vinegar. The cotton should be dipped, squeezed, and gently swabbed over the print. When the print is dry, use a new, fresh coater to spread the protective finish over the print.

Polaroid markets a variety of films in Packs, Rolls, and Sheets. Your particular camera and your picture-making needs dictate which films you'll want to learn about.

THE PACK FILMS

Polacolor Land film Type 108 delivers a finished full color print after 60 seconds development. Prints are grainless and the film renders excellent flesh tones and full shadow detail. Polacolor does not require any coating to preserve the image. It has a 75 speed emulsion, color balanced for 5500 degrees Kelvin for use in daylight and with electronic flash or blue flashcubes or flashbulbs. Small variations in development time will control the overall color tones of the print; underdeveloping will yield warmer tones and overdeveloping gives bluer tones. Standard color correction filters will also influence the color rendition of the print.

Polaroid Type 107 Land film carries a black and white emulsion producing a positive print with a rich tonal-range in 15 seconds. Type 107 is an ultra-sensitive 3000 speed film with medium contrast range. This film is ideal for general picture-making as well as available light photography in low light levels.

Polaroid Land film Type 105 P/N produces a black and white positive print AND a fine-grain negative. It has a 75 speed emulsion requiring 20 seconds development.

THE ROLL FILMS

Polacolor Type 48 Land film offers the same full color prints as Type 58 sheet film or Type 108 pack film. This 75 speed film is balanced for daylight or electronic flash.

Polaroid Land Type 42 film offers fine-grained paper prints with an excellent tonal range. A 200 speed film, it is the choice for many serious photographers who demand maximum photographic quality in black and white prints. Prints are made permanent by a simple coating solution. Type 47 Land film offers the same characteristics and speed as Type 107. The ultra-fast Polaroid emulsion with a 3000 speed was introduced on Type 47 in 1969. Still the fastest general purpose film, Type 47 serves for a variety of additional applications in science and industry. The prints must be coated for permanence.

Polaline Type 146-L Land film is a blue-sensitive material designed to produce ultra-high contrast transparancies with 30 seconds development. Film speed under tungsten illumination is 100. This film will record line copy as black on white, with no grey tones. Both Type 46L and Type 146L transparencies must be hardened in the Polaroid Dippit before mounting. Type 146-L transparencies can be ready for projection within two minutes of exposure.

Polaroid Type 46-L Land film is a high-speed, medium contrast panchromatic emulsion designed to produce black and white continuous tone transparencies with two minutes development. Four full-frame 35 mm images may be reproduced on one frame of the lantern slide-format film.

Polascope Type 410 Land film, at 10,000 ASA equivalent, was specifically designed for recording with low light level sources, such as short duration oscilloscope traces, high magnification photomicrography, high speed events, and other scientific applications. This film is not recommended for general purpose photography.

3 NATURAL LIGHT

Photograph by C. Tyler Quillen

Photograph by Robert Seitz

The acknowledged master of natural light photography, Ansel Adams has said, "Light is as much an actuality as is substance such as rock or flesh. It is an element to be evaluated and interpreted. The impression of light and the impression of substance which are achieved through careful use of light are equally essential to the realistic photographic image."

BECOMING AWARE OF LIGHT

One of the primary differences between a casual snapshooter and an experienced photographer is that the latter has highly developed powers of observation. To learn to make good pictures, like the acquisition of any other skill requires practice—practice in observing light, since light more than the mechanics of camera operation usually determines the quality of your finished photograph.

There are several ways to develop your ability to see with a photographer's eye. Study every lighting effect you like in actual scenes and in photographs. If you're interested in landscapes, check out a book of pictures from your library, perhaps one of Ansel Adam's books. Try to imagine the photographer's reaction while trying to make the photograph, trying to find the right time, the right light, look closely at the shadows, at the sky, at how light is reflected from the subject. If you can imagine a quality of light in your mind's eye as you look at a scene or subject, you should better be able to recognize it or to estimate when that kind of light exists.

Every where you go, in everything you do, the opportunities for observing light are unlimited. Look critically at the lighting on television, in motion pictures, when walking through the park, while riding a bus. Watch the light on people, on buildings, on anything. Look at the lighting effects in your own living room.

There's a maze of shadows, of shapes. Notice how various objects are revealed according to the angle of the light source falling on them.

As you look at, study, and explore light, try to "pre-visualize" how this light would look in a photographic print. Carry a camera with you. *Photograph light*—the light on the trunk of a tree, the light on the face of a child, the light on a building. Use your camera and film as a sketchbook to build a visual library of light.

This informal portrait was illuminated by natural light from a large window. Where possible, use a tripod to eliminate any possibility of blurred pictures caused by camera movement during the longer than normal exposure. Photograph by Lynne Bentley-Kemp.

The technique called "panning" was used to catch the fast action of youthful exuberance. Panning means to follow the action by moving the camera with the subject, making the exposure while both camera and subject are in motion. This technique will result in slightly blurred backgrounds while retaining crisp detail in your action subject.

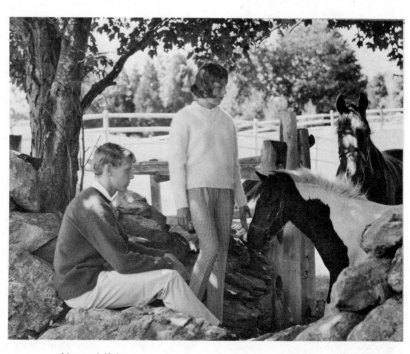

Natural light on a cloudy-bright day set the casual mood for this picture. Suggesting an appropriate activity for your subjects helps them forget about the camera and avoids stiff awkward "posing"

NATURAL LIGHT HAS MANY MOODS

Even now, some people adhere to the old adage, "Take pictures after 10 in the morning and before 2 in the afternoon, with the sun at your back." The first time you break the rules by trying to make a photograph at dawn or in the rain, you'll be astonished at the results. The tones will differ from those at midday in the sun. Some of the most beautiful photographs are those which ignore the rules and take advantage of the infinite variety of tones provided by natural light.

The day follows a predictable light cycle. *Dawn*—in the earliest hours of the day the world is essentially black and gray. The light exhibits a cool, almost shadowless quality. Colors are mutes; they change slowly, although right up to the moment of sunrise they remain opalescent and flat.

Early morning—as soon as the sun is up the light changes dramatically. Because the sun is so low and must penetrate such a great amount of atmosphere, the light that gets through is much warmer in color than it will be later in the day. Shadows look bluish because they lack the high, brilliant, cold sunlight, and because the great amount of blue from the overhead sky.

Midday—the higher the sun climbs in the sky, the more the contrast between colors. At noon the light may be harsh, stark, crisp. Colors stand out strongly, each in its own hue. The shadows are black and deep.

Late afternoon—as the sun drops towards the horizon the lights begins to warm up again. It's a very gradual warming and should be observed carefully. On a clear evening objects will begin to take on an unearthly glow. The shadows will lengthen and become bluer. Surfaces will become strongly textured. Increasing amount of detail will be revealed as the sun gets lower.

Evening—after sunset there is still a great amount of light in the sky, often with sunset colors reflected from the clouds. Just as at dawn, the light is very soft, and contrasts between tones and colors is at a minimum. Finally the world again becomes a pattern of blacks and grays.

PICTURE-MAKING WEATHER

There really is no such thing as bad weather for photographs. Fog gives pearly, opalescent, muted tones. Storms add drama and a sense of mystery. Rains mutes some colors and enriches others, while creating glossy surfaces with brilliant reflections.

The definition of good light depends on the photographer's intent. To utilize natural light fully, you must know how to

evaluate its intensities and qualities, not only in their effect on sensitive emulsions but also in relationship to the intangible elements of insight and emotion that are expressed in a good photograph. An esthetic awareness is involved, something more than the physical conditions of light and exposure.

COMPOSITION

Edward Weston said, "Good composition is the strongest way of seeing." Photographic composition is simply the selection and arrangement of subjects within the picture area.

Some arrangements are made by placing figures or objects in certain positions. Others are made by choosing a point of view. You may move your camera a few inches or a few feet and change the composition decidedly. Some "chance shots" may turn out to have good composition, but most good pictures are created. How do you create a picture? First you learn the guidelines for good composition and realize that most pictures with good composition take careful planning, and sometimes patient waiting. But it's not as hard as it may seem. You'll find that the guidelines of composition will become part of your thinking when you are looking for pictures, and soon they will become second nature to you.

The subjects in this tightly composed action photo form a rough "circle" or center of interest. The exposure was made at the moment when the leaping husky reached the apex of its jump. This technique of shooting at the peak of action helps freeze any subject motion.

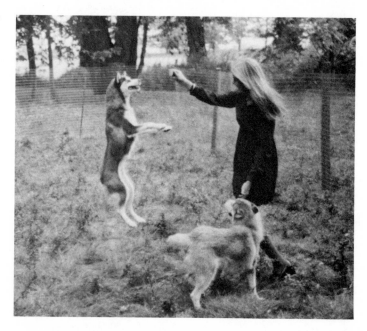

Composition: The strongest way of seeing

PLAN FOR A STRONG CENTER OF INTEREST

Have one strong center of interest. You may want to include a secondary subject, but make sure that it doesn't detract from your main subject.

Avoid putting your center of interest in the center of your picture. If the main subject is smack in the middle of the picture, it looks static and uninteresting.

KNOW THE ANGLES

When you find a subject, don't just walk up to it and snap the shutter. Walk around the subject and look at it from all angles; then select the best angle to shoot from. Shooting from a low angle provides an uncluttered sky background: outdoors. However, in bad weather you'll want to shoot from a high angle and keep the sky out of the picture. Overcast skies look bleak and unappealing in pictures.

Consider the horizon line. Never cut your picture in half by having the horizon in the middle of the picture. You can have the horizon low to accent spaciousness—especially nice if you have some white, fluffy clouds against a blue sky—or high to suggest closeness.

MOVE IN CLOSE

Some amateur photographers look through the viewfinder and start backing away from the subject. This is not only bad from a safety point of view, but it can also be bad for composition! When you look through your viewfinder, move toward your subject until you have eliminated everything that does not add to your picture. Even though you can crop your picture later if you plan to enlarge it, it's always better to crop carefully when you take the picture.

Take closeups to convey a feeling of intimacy, and long shots for airiness and depth.

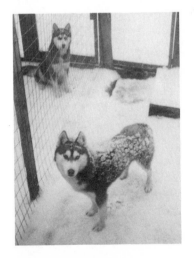

A high angle of view and tight composition were used in this view of the author's prized Siberian Huskies. A "cold clip" was used to avoid processing problems in the cold.

Photograph by Hank Kennedy

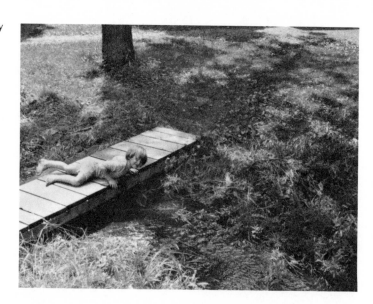

Photograph by Steven Zoref

USE LEADING LINES

Lines should lead into, not out of, the picture. A leading line can be almost anything, such as a road, or a shadow. The road will always be there; it's just a matter of choosing the right angle to make it lead into the picture. A shadow, however, is an ever-changing thing. There may be only one time in the day when it is just right. So if possible, be patient and wait for the good composition.

WATCH THE BACKGROUND

The background can make or break a picture. It can add to the composition and help set the "mood" of a picture, but it can also be very distracting if it is cluttered. Before you snap the shutter, stop for a minute and look at the background. Is there a telephone pole "growing" out of your subject's head? Beware of an uncovered trellis or the side of a shingled house when you take informal portraits or groups, because prominent horizontal or vertical lines always detract from your subject. Foliage makes a better background. A blue sky is an excellent background, particularly in color pictures. Remember, look beyond your subject—because your camera will.

ADD INTEREST TO YOUR SCENIC SHOTS

In scenic shots, it is often a help rather than a hindrance to include people who may be in the field of view. They should, however, look at the scene—not at the camera—and they should be at least 25 feet from the camera. For color pictures, have your "foreground figures" wear colorful clothing, preferably red or yellow, to add color and interest.

Frame your scenics with an interesting foreground, such as a tree or a branch. Watch the depth of field so that both the foreground and the scene will be in focus. It is very distracting to have an out-of-focus foreground.

To repeat, composition is simply the selection and arrangement of objects within the picture area. If you follow the suggestions given here, your own experience will teach you a great deal about this subject. When you look through the viewfinder, have the whole picture in mind.

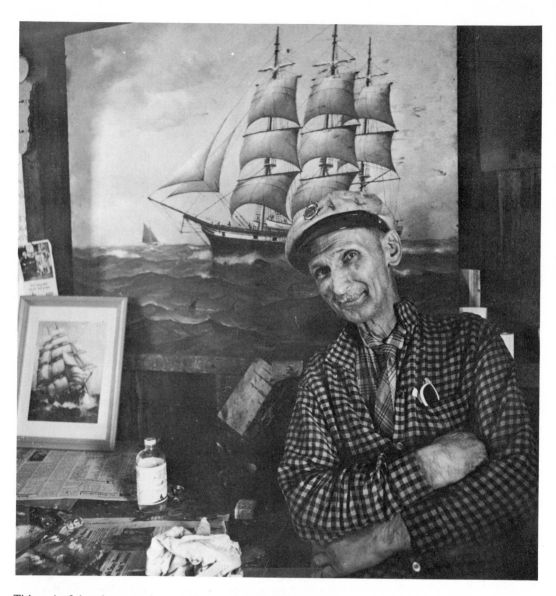

This colorful artist was photographed in his dockside studio in Mystic, Connecticut. The tungsten overhead light fixture provided plenty of illumination to make the photograph with a tripod mounted camera.

4 ARTIFICIAL LIGHT

An assortment of studio lights

With today's fast films, lenses, and lighting equipment, no one has to wait for the sun to come out to take photographs. Positioning your subject near a large window will provide beautiful and adequate light for fine pictures. In many situations a supplementary light source can do much to improve photographs, bringing out the detail in shadows, giving an impression of three dimensions, or providing special dramatic effects.

It may be preferable to use flood lights or spot lights when circumstances permit. Their continuous light is easily controlled so that the pattern of illumination—the highlights and the shadows—can be manipulated to suit the visual requirements. Very effective photographs with artificial light can be made with simple equipment.

Lighting has a tremendous influence on characteristics of a subject. It can enhance or idealize, distort or destroy. It is not unusual for a photograph to be judged on whether the lighting alone is a success or failure.

Successful lighting depends upon the photographer's ability to be aware of and accept the physical limitations of his medium, and his skill and ability to see and arrange the light in a scene with good taste and judgment. For most subjects there should be one dominant light source and enough secondary illumination to fill in the shadows. When confronted with the problem of artificially lighting a subject or situation it's extremely important to see with a camera's eye, to look at things in terms of *light*. *A camera does not reproduce the subject; it simply records the light reflected from the subject.*

The effect of any direct light source is controlled by:

• changing the angle at which the light strikes the subject by raising or lowering the unit,

• varying the distance between the light and the subject, and or

• varying the position of the light so it shines from behind the subject, in front of the subject, or from any other point around the subject.

These are the three most common controls. Others include modifying the quality of the light with diffusion screens or color filters, varying the voltage being fed to one or more of the lights, or modulating the light with shields or shades.

WORKING WITH STUDIO LIGHTS

Solving any lighting problems depends first on an understanding of the principles involved, then patient manipulation of the lights. A combination of flood lights and spot lights permits concise control over the results of a photograph. Continuous light can be turned on or off at will, making it possible to immediately observe the effects the lights and their placement actually produce, and to control these effects by moving lights and reflectors around until the illumination is appropriate for the subject.

Basic lighting is concerned with creating a natural and attractive lighting which simulates an *outdoor* effect. The word *outdoor* is emphasized because outdoor lighting is the standard of comparison for most lighting. People are accustomed to seeing things by outdoor lighting; therefore, the following principles should be considered in using artificial light:

• It is important for light from the main source to come from above, usually at a 40 to 60 degree angle to the subject, because that is the customary sun angle by which most objects are viewed outdoors.

• Just as outdoors there is one sun creating one set of shadows, an indoor studio lighting setup must have one dominant light source and one set of dominant shadows if it is to appear natural.

• Outdoors, no matter what contrasts the sunlight creates, our eyes can always discern shadow detail because of their variable sensitivity. Therefore, average studio lighting should always have sufficient shadow illumination.

• The outdoor effect of overcast days has its counterpart in shadowless studio lighting for shiny-object photography. This directionless lighting has also found new use in modern color photography where the color itself renders many more objects adaptable to this treatment than if the photograph were in black and white.

Tips for better flash pictures

The SX-70 camera opens up a new world of close-up photography. Without having to change lenses you can come as close as 10 inches for detail-filled close-ups. Photograph by Carl Schultz.

Select the best distance from your subject. A common picture making error is to stand too far away. Don't try to get too much into one picture. Be selective and include only what you want to show. Photograph by Donna Southworth.

An example of the soft and natural light characteristic of bounce lighting.

PICTURES WITH BOUNCE LIGHT

There are several good reasons for taking pictures by bounce light. First of all, it's easy. Second, it produces a very soft and natural type of lighting—there are no dark shadows. Third, by aiming the light toward the ceiling you'll obtain even lighting in the general vicinity of the light. This means that in many rooms you won't have to change exposure settings on your camera when your subject moves around the room.

To use bounce lighting point your photolamps at the ceiling so the light will bounce off the ceiling and illuminate your subject. You can take pictures if you have an adjustable camera with a fast lens (f/1.9 or f/2.8). You can use any reflector-type photolamp for bounce lighting. A movie light works fine; if you have one, use it. If you're taking color pictures the ceiling must be a white or a light gray; a colored ceiling would reflect its color on to your subject.

When you use bounce light your subject won't be as brightly lighted as he is when the lights are pointed directly toward him. For this reason, it's necessary to use a fast film such as Type 107

for black and white prints. If your camera isn't automatic use an exposure meter to determine correct shutter speed and lens opening.

A "ghost-image" may be the result of making a flash picture in a area which has bright natural light. Photograph by Robert Seitz.

FLASH SYNCHRONIZATION

When you take flash pictures with cameras that have adjustable shutter speeds, use a speed the instruction manual recommends. With some cameras you should take flash pictures only at a shutter speed of 1/30 second. (Check your camera instruction manual to see if this applies to your camera.)

If you try to make flash pictures at higher speeds you'll get badly underexposed pictures or no pictures at all. Some cameras have flash synchronization settings marked X and M. The X setting is a no-delay setting for use with electronic flash units at any shutter speed, and for use with flashcubes, AG-1B flashbulbs, and number 5B, 25B, and M3B bulbs at a shutter speed of 1/30 second. With an M setting and the flashbulbs listed above, make flash pictures at all shutter speeds. M2B flashbulbs can be used only with the X setting and shutter speeds up to 1/30 second. If you're ever in doubt about which synchronization setting to use, use the X setting and a shutter speed of 1/30 second. This combination works with any kind of flash bulb or electronic flash.

Mount one of your favorite Po-
laroid color photographs over
this rectangle with an adhesive
such as Elmer's Glue.

5 POLAROID COLOR PHOTOGRAPHY

COLOR PHOTOGRAPHS IN A MINUTE

Color adds an exciting dimension to almost any photographic subject, from the snapshot of the family pet to the carefully planned and executed magazine ad. Color has possibilities of multiplying a picture's impact in many ways. In the hands of an adventurous photographer, color can bring out the subtleties of a person and his many-faceted emotions. Color can be its own justification. The pure, simple beauty of color can be the success factor in views of wildflowers, tranquil oceans, fiery sunsets, misty harbors, and the garishly painted clowns of the world's circuses.

The immediacy of Polaroid color pictures is like an instant-replay on television; allowing you to enjoy, appreciate, and analyze a special fleeting moment—and to preserve it. SX-70 color pictures add the bonus of permitting you to observe a chemical and physical re-creation of your moment preserved. When ejected from the camera the print carries a blue-green square which slowly changes into a brilliant color picture.

Polaroid color film became available in 1963 with the introduction of Polacolor; yielding a color print that developed in sixty seconds. This is the film for color pictures with all Polaroid cameras except the SX-70 Land camera.

The chemistry on which the processing of Polacolor is based is extremely complex. It is a subtractive-type color film in which dyes for the three colors—cyan, magenta, and yellow—in various combinations, yield the full palette of colors in a finished print. The remarkable thing about Polaroid color films is that all the processing chemicals must be included in a package of film small enough to fit inside a relatively compact camera. Polacolor film employs a dye-diffusion system for getting the colors from the negative to the positive paper. Contained within a cross section of

the film, no thicker than half a human hair, are the six color layers required to form the negative image, three layers of emulsion, four other layers that form positive images, and a layer containing a pod of alkaline chemicals which trigger the processing.

The wonder of Polaroid color film is that, despite the bewildering lights and hues of the world, it can meet nearly every challenge.

Photocolor Data

Achieving good and consistent results with Polacolor film is possible with careful attention to the following factors:

* Development time
* Development temperature
* Speed of pull
* Proper storage

DEVELOPMENT TIME

Development begins the instant the picture is pulled through the rollers and ends the instant that the positive is separated from the negative or peeled. With Polaroid black and white films, a very slight increase in contrast results from developing longer than the recommended time. Polacolor is much more sensitive. Underdevelopment of Polacolor results in reddish or warmish tones that tend to be flat and muddy. Overdevelopment with Polacolor results in increased contrast, increased color saturation, and a strong shift in color balance toward blue or cyan. As little as ten extra seconds will produce this shift toward blue. For pictures with optimal color balance, a development time of precisely sixty seconds is essential.

You can take advantage of this increase in contrast and saturation by purposely overdeveloping, and compensating for the color shift with warming filtration. Experience has shown that a magenta color compensating filter works best. The necessary strength of the filter may be generalized as follows: for every 20 seconds of overdevelopment, filter CC10M. In this way, a development time of 80 seconds would require warming filtration of CC10M; 100 seconds would require CC20M; and 120 seconds would require CC30M.

TEMPERATURE

The 60 second development time is recommended only when the temperature is between 75° and 85° F. For temperatures outside this range, development time must be increased if higher and decreased if lower. See the tip sheet for details.

SX-70 Color Data

Unlike Polacolor the SX-70 color picture is formed over the covered negative image. To eliminate the useless trash-producing negative, a way was found to make the negative an invisible part of the finished picture. To combine the negative and picture, the inventors had to change the usual way in which Polaroid pictures were made and viewed. Their solution was to cause the image to form on clear plastic in such a way that it would be viewed from back to front, through the plastic. The bright white background for the positive dye image is formed by a thin layer of intensely white pigment spread between the light sensitive emulsion and the plastic cover when the print is forced through rollers and ejected from the camera to develop. The cyan, magenta, and yellow dyes form the photographic image on the pigment. The exceptionally brilliant and vivid color picture is illuminated by viewing light bouncing from the pigment back through the layers of color. The white pigment conveniently hides the no longer needed negative.

SX-70 film combines both negative and print in one permanent sheet assembly. The sheets form a thin 10-exposure film pack that is inserted in the base of the camera. A developing pod containing just enough chemicals to develop that sheet is positioned along one edge of each section of the film. The pod contains a developing alkali, the white pigment, and a liquid light-shield. The light-shield is an ingenious substance which blocks harmful light until the finished picture is formed. Called an "opacifier," it works like the kit for testing water in the family pool; an indicator which changes color when the alkalinity/acidity ratio is varied. When the print is forced through rollers, rupturing the chemical pod, the opacifier is spread over the negative, instantly forming a blue-green light-blocking shield. As the picture dyes form causing the processing chemical to lose its alkalinity, the opacifier reacts and clears until it's transparent.

In a "conventional" camera this solution would result in a left-to-right reversed, "backwards" image. For the SX-70 inventors, it was an incredible bonus; allowing them to place a mirror between the lens and film. The mirror reversed the optical image

from the lens so that it struck the film "backwards" and appeared as it should when viewed through the plastic cover of the finished picture. A mirror reduced the physical lens-to-film distance by "bending" the light path, making the light rays travel a distance greater than the actual distance from lens to film. This "bending" of the light path permitted the more compact camera design.

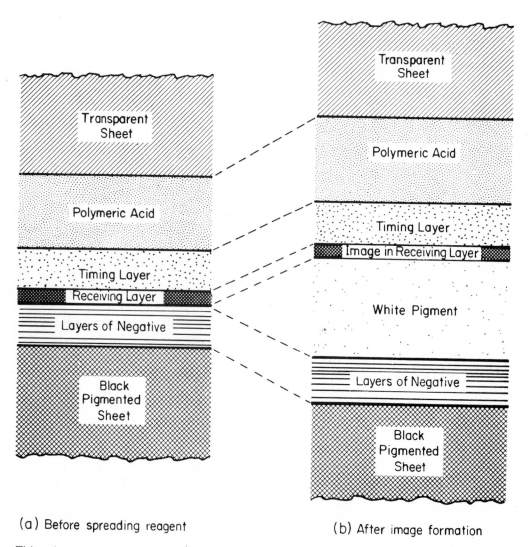

(a) Before spreading reagent

(b) After image formation

This schematic cross-section shows an integral SX-70 film unit before and after development. It is drawn approximately to scale. The white pigment seen in the cross-section at right is spread with the reagent during processing and forms a highly reflective surface behind the color image contributing to its brilliance.

The film is designed for "infinity" development. This means that it develops until the chemicals are completely exhausted. The success of the process depends on the use of precisely the right amount of "secret" chemicals.

Speaking of the SX-70 system, Dr. Edwin Land, founder, president, and director of research of Polaroid Corporation, said, "It can make a person pause in his rush through life, and in the process enrich his life at that moment. This happens as you focus through the viewfinder. It is not merely the camera you are focusing; you are focusing yourself. That is an integration of your personality, right that second. Then when you touch the (shutter) button, what is inside you comes out."

Land feels that through instant photography, people will learn to look, to feel, and to remember in unique new ways.

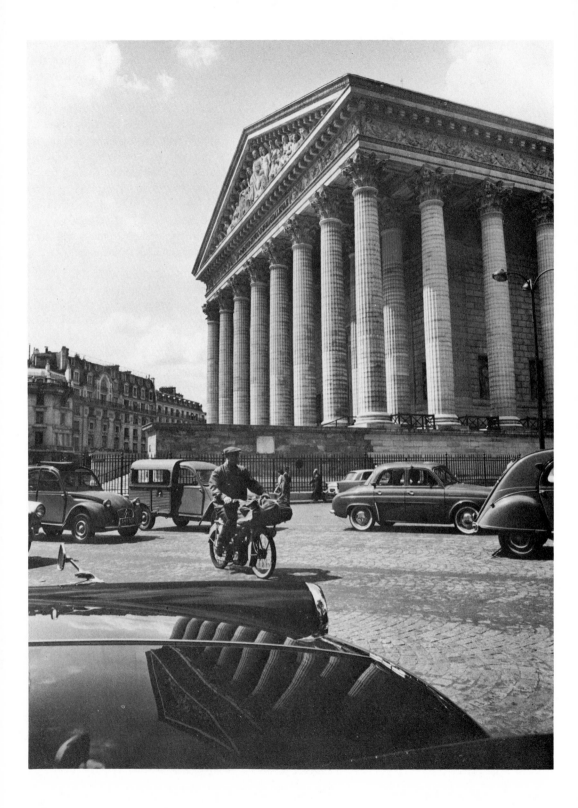

6 THE WORLD IN PICTURES

Polaroid photography has become so widespread that many people now take instant pictures for granted. Despite this, no one fails to respond to their own image and presenting someone a fresh picture of themselves is a great social ice breaker and a dependable conversation starter.

A Polaroid print of you and travel friends, taken in front of a famous foreign landmark, attached to a Polaroid postcard, and sent home is bound to have more appeal than the commercial, impersonal cards available by the thousands in tourism locales all over the world.

In the course of photographing strangers and sharing your pictures with them, there's one thing to beware of: how do you avoid giving away the pictures? One solution is to make two photographs. Take the first one, pull the tab for processing, and expose the second while the first is developing. The new SX-70 Land camera is perfect for fast shooting.

If you don't plan on showing the photograph to the subject, wait until you're away from him before pulling the tab for processing. This delayed processing technique can be quite frustrating, but it's also a useful technique when you're making candid pictures. If you're doing all your vacation and traveling photography with a Polaroid you must be careful about giving away the prints, or you'll find yourself back home with little or no photographic record of your travels and adventures.

AN INSTANT PASSPORT TO ADVENTURE

Travelers have used the "magic" of Polaroid to dissolve the natural suspicion and hostility of primitive peoples. Polaroid photos developed on the spot and presented within moments after being taken are "ice breakers" in any travel encounter.

The Madeleine Church, Paris

41

There are scores of stories detailing how Polaroid pictures have made travel considerably easier—gaining needed special services at hotels, opening doors to private art collections, establishing instant rapport with foreign counterparts, and permitting photography of people, places, and events previously "off limits." Polaroid pictures get the credit as a catalyst for innumerable lasting international friendships.

One enterprising traveler used Polaroid snapshots to finance and enhance a memorable six-week tour of France, Spain and North Africa.

VACATION FILM SUPPLY

Experienced travelers will tell you to stock up on fresh film before your holiday. Although the manufacturer maintains an extensive international program for product distribution and film is available in most of the world's larger cities, the prices will vary because of local import duties and taxes. Of one thing you can be certain; film purchased abroad will be more expensive and probably closer to the expiration date on the package.

Take as much film with you as you can manage. Even though it makes a bulky package, it's a self-liquidating one. Beware: don't use the space-saving trick of discarding the outer boxes—they're important for protection of the chemical pods that you must depend on for instant processing. If the pods get ruptured, the chemicals may dry out and the film will be made useless.

CUSTOMS VS. YOUR FILM SUPPLY

Many nations have restrictions on the quantity of film that can be brought in by visitors. It's a good idea to disperse your film supply throughout your luggage—put a few rolls or packs in the airline bag, and place other portions of the supply in various nooks and crannies of your travel cases. The more you appear to be a camera-happy tourist, the less hassle you'll get from zealous customs inspectors. The idea is to avoid giving the impression of carrying an unusually large quantity of foreign (to the customs agent) film with you.

If a problem should come up over the quantity of film you're carrying, it's often possible to leave the excess in bond with the customs office and reclaim it when you leave that country.

TIPS FOR PHOTOGRAPHING YOUR TRIP ABROAD

The second nicest thing about traveling is reminiscing afterwards—both by yourself and with friends. And one of the best

ways to remember is with pictures. It's easy to describe the Leaning Tower of Pisa to someone at home, because he can instantly form a mental image of the familiar landmark. But describing the view of the city from the top of the Tower may not be so easy. This is when a picture is worth a thousand words.

Pictures show the stimulating and colorful array of sights that you'll find wherever you travel. Your pictures should also reveal your impressions of the countries you visited, and show what you learned about these lands and their people. You may be interested in the history, festivals, or fun spots—most likely a mixture of all these. The pictures you take will stimulate your own memories and provide others with vivid documentation of your travels.

PLANNING AHEAD

In planning your trip, it's a good idea to make research notes about the countries you plan to visit. Anticipate things you want to do in a particular country. Many of your most rewarding picture situations will coincide with the highlights of your trip.

A CAMERA FOR TRAVEL PHOTOS

A complicated camera is unnecessary. Even the simplest camera can produce good pictures in sunlight.

If you demand a collection of good pictures of your travels, never take a camera that is a stranger to you. If you expect to acquire a new camera for the trip, pick it up well in advance of the journey and expose at least a couple of rolls under simulated trip conditions. Have the film processed so that you may carefully examine the results and correct any picture-making problems.

If you don't want to be bothered with making exposure calculations and settings, use a simple or automatic camera. However, if you have or know how to operate one of the adjustable cameras you can depend on it to extend your picture-making options.

WHAT TO PHOTOGRAPH

When you travel, photograph what interests you. Don't limit yourself to only the beaten paths leading to the Arc de Triomphe, the Colosseum, or the Matterhorn. If you bring back only a "picture postcard" collection of photographs, you've missed a lot of the fun of being abroad, and missed some good pictures, too. To get interesting, unusual pictures, allow some leisure time to visit

fairs, fiestas, and various shops, and to take other interesting side trips. Many local photo dealers will be glad to give you good picture-taking ideas. You can also consult city guides and maps to find places of interest.

When taking scenic pictures, remember to include people in the foreground for color and interest. If possible, have them wear bright clothing. Ask them to do something natural so that they won't stand stiffly in front of the camera.

Titles help tell your audience where you went. Photograph natural titles such as signposts, historical markers, and familiar landmarks. Get pictures of your departure and your arrival back in the United States. When you arrive in a country—in England, for example—take title pictures of well-known landmarks, such as Big Ben and Tower Bridge, London, to introduce your pictures of that country.

If you have a camera with a fast lens and remembered to bring a compact but sturdy tripod try taking existing light pictures of well-lighted interiors, and of brightly illuminated outdoor subjects at dusk or after dark. These pictures will enrich and vary your picture collection.

PICTURE PROCRASTINATION

Postponing picture-taking because of bad weather or because your camera is packed is "picture procrastination." Always keep your camera handy. Take pictures even if it's cloudy; you probably won't have a second chance because your travel schedule won't permit. Your film instruction sheet will tell you how to photograph under cloudy conditions. Take the picture even when weather conditions aren't ideal; you'll usually be glad you did. If your camera has a fixed lens opening, color pictures taken on cloudy days may be too dark, but probably better than none at all.

PICTURE-TAKING ON THE GO

What about picture-taking from a moving plane, train, or bus when you can't stop to take pictures? Pictures that you take from moving vehicles with a simple camera are likely to be blurred, because the camera doesn't have a shutter speed fast enough to "stop" movement. But it's not impossible to get acceptable results if you keep a few techniques in mind. Here are some hints that should help you to get the best possible pictures under the circumstances.

- Photograph only scenes that are far away. Nearby subjects will be blurred.
- It's best to photograph subjects that you are approaching or have already passed. Movement is less apparent when you're moving toward or going away from the subject.
- Take pictures from the shaded side of the vehicle so that the sun will be behind you.
- Hold your camera as close to the window as possible to reduce reflections. However, don't hold the camera against the window or brace yourself against a part of the vehicle, because the vibration may blur your pictures.
- If you have an adjustable camera, use a shutter speed of 1/250 second or faster, if possible to stop movement.

CARE OF YOUR CAMERA AND FILM

Protect your camera by keeping it in your camera case. Most likely your camera will be swinging freely on the end of your neck strap during most of the trip. Bumps and scratches and its lens could spoil your travel photos.

Don't store your camera and film in sunlight or in a hot place such as the glove compartment, dashboard, or rear window shelf of your car. Heat can harm the camera and film. When storing your equipment in a car, put it on the floor behind the front seat on the side opposite the exhaust pipe. To help get sharp pictures, keep the camera lens clean. Blow away any dust, or brush it away with a camel's hair brush; then gently wipe the lens with a clean, soft, lintless cloth or lens cleaning paper.

The old city and harbor at San Juan, Puerto Rico.

45

Picture making during an airplane trip

If you are traveling by plane, you will have the opportunity to record your trip from an unusual point of view.

VARIOUS SUBJECTS TO PHOTOGRAPH

Here are some suggestions of objects you may want to capture on color film the next time you fly.

- Unique features of the airport, such as unusual architecture and mosaic murals.
- Members of your family standing near the plane steps, ready to board.
- The airport and its surroundings from the air. You'll get the best pictures of subjects on the ground right after takeoff and right before landing, because these subjects will produce images large enough to be clearly recognizable in your pictures. If you are too high, buildings and other subjects on the ground will look like small dots.
- Expansive city skylines, intricate highway patterns, checkerboard farmlands, and snowcapped mountain ranges.
- Colorful sunsets and delicate or stormy cloud formations. Include the plane's wing in the foreground when making pictures of these subjects to add depth and interest.

HELPFUL HINTS

The following suggestions will help you make good pictures from the plane, no matter what camera and film you are using.

- Try to be near the front of the boarding line so that you will be able to choose the "right" seat for making pictures. The "right" seat is next to a window, in front of or behind the wing (so your view of the ground will not be obstructed), and on the shady side of the plane during flight. If the sun shines in the window next to you, dirt and scratches on the window may cause flare in your pictures. The stewardess will gladly tell you which will be the shady side.
- Hold your camera steady. Don't let it touch the window and don't brace your hands or arms against any part of the plane, because vibrations can cause blurry pictures. Squeeze the shutter release gently.

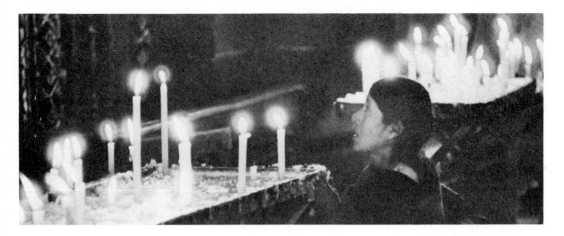

Quechuan Indian, Cuzco, Peru

Picturing the world's peoples

Caped University Student, Torremolinos, Spain

• Before takeoff, load your camera and set any necessary adjustments for low-altitude pictures.

ADJUSTING YOUR CAMERA

If your camera does not have any manual adjustments, just aim and gently squeeze the shutter release. If you have an adjustable or semi-automatic camera, set it according to these recommendations.

• Shutter speed. Use 1/250 second (or as close to this as possible).

• Focus. Set the focus at 50 feet. At 50 feet the plane wing and everything beyond it will be in focus. Any dirt or scratches on the window will be out of focus.

• Lens opening.. Read the exposure recommendations printed on the film instruction sheet packaged with your film. Select the pertinent lighting condition in the daylight exposure table—bright or hazy sun, cloudy bright, etc. At low altitudes, use the same f/number that you would on the ground. At high altitudes, where things look brighter, use one stop less exposure than you would on the ground for similar weather conditions, for example F/11 instead of f/8. An automatic camera will make this adjustment for you.

HAZE

The higher you are flying, the more haze there will be between you and the ground. Haze makes color pictures look bluish because it reflects ultraviolet radiation. If you want to reduce this effect, use a skylight filter over your lens. This filter requires no exposure compensation.

7 PROFESSIONAL PRODUCTS AND TECHNIQUES

Model 195 Polaroid Land camera.

Film pack holder Model 405 and negative holding tank.

THE POLAROID PROFESSIONAL PACK CAMERA

The vast majority of the millions of photographers who use Polaroid equipment demand the simplest possible camera with the maximum of automatic features. By contrast, advanced amateurs and professionals insist on a camera with a minimum of automatic features. Advanced workers in photography insist on having a camera which will allow them to control the size of the aperture and the shutter speed. Through the years, Polaroid has responded to this need. First with the Pathfinder cameras using the roll films, then with the Polaroid 180 Professional Pack camera, and now the updated version; the Polaroid 190 camera.

This camera features a fast 114 mm Tominon f3.8 lens. It has all the shutter speeds from 1 second to 1/500th as well as bulb. It has electronic and conventional flash synchronization. It employs a bright image coupled-rangefinder system.

THE NEW TYPE 105 P/N FILM

Popular Photography magazine, in its report on this new camera, correctly predicted that something else was cooking in the Polaroid's Film Research and Development Laboratory—that in the near future a new film would be marketed which would give both a high quality positive print and, simultaneously, an extremely fine-grain negative for immediate enlargements. Just recently, Polaroid has introduced Type 105 P/N Land Film packs.

This new film offers immediate access to a print with smooth gradation over a full tonal range on a super-white base for greater luminosity. The positive image is of high acutance for good rendition of fine detail with smooth even tones in a fine grain emulsion.

The negative carries a medium contrast and very fine grain image with wide latitude. A polyester base promotes quick drying

Polaroid's new film for black and white prints and negatives

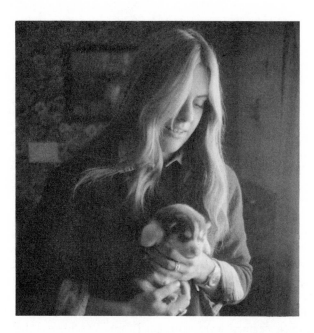

Photograph by Weston Kemp

Photograph by Robert Seitz

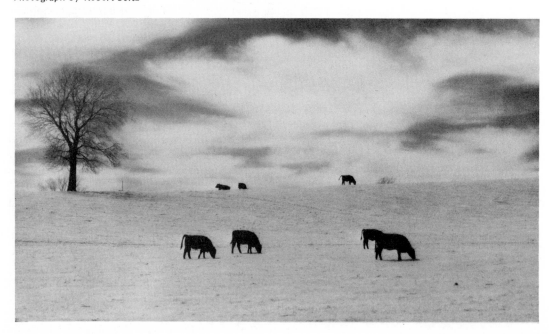

and good dimensional stability. The film has been designed so that an optimum quality negative would result from the exposure, producing the most pleasing positive print; no mean accomplishment considering the complexity of the technologies involved.

This new positive/negative film pack is less expensive than the Type 55 P/N designe;for use in large format professional cameras such as the 4 X 5 Speed Graphic. It has the potential for producing comparable enlargements with less bulk and easier loading.

Type 105 P/N is compatible for use in all Polaroid cameras which can use Type 107 (high speed black and white film) and Type 108 Polacolor. Since it is the same film speed as Polacolor, anyone can switch to this positive/negative film when black and white enlargements are needed. Anyone who owns any of the folding pack cameras; 100s, 200s, 300s, 400s, 180, and premium cameras as well as all 100-series non-folding cameras, can now use this new film. This film can also be used in the Polaroid MP-4 Industrial View camera, the CU-5 Close up camera. the CR-9, ED-10, and all CB-100 Camera Backs. The CB-100 Camera Back adapts non-Polaroid cameras for instant photography. This adapter back can be used with such cameras as: Bronica, Hasselblad, Nikon F, Graflex XL, Mamiya RB67, and a variety of press and view cameras.

Type 105 P/N is a panchromatic film which develops in thirty seconds. It is rated at 75 ASA and produces a 2 7/8 X 3 3/4 inch image on a 3¼ X 4¼ print. The negative has a resolution of 160-180 line-pairs per millimeter, with a 7-stop dynamic range.

To prepare the negative for enlarging, the soluable opaque back coating and processing chemical residue is removed in a simple 12% sodium sulfite solution. The negative is then washed and dried normally. Polaroid markets a portable tank for field use which is packed with sodium sulfite and a measuring cup. The user has only to add water.

THE POLAROID 4 X 5 LAND FILM HOLDER

The Polaroid 4 X 5 film holder allows the advanced photographer to adapt almost any 4 X 5 camera to the Polaroid instant photography process. It allows you to make pictures on the spot with almost any 4 X 5 camera or scientific instrument. The holder fits locking or springback-type cameras designed to accommodate regular 4 X 5 sheet film holders. No alteration of the camera, its film plane, or its focusing system is necessary. The Polaroid film holder is positioned in the back of the camera the same way as a regular 4 X 5 holder.

Polaroid's 4 x 5 Land film holder

HOW THE HOLDER WORKS

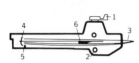

1. Loading film: With control arm (1) at L, rollers (2) are apart so film packet (3) can pass through freely. Cap (4) is held by spring loaded retainer (5). Layers of film packet are, from bottom to top: protective envelope, non-light sensitive positive print sheet, light sensitive negative secured to cap (4), protective envelope. Pod of developer (6) is attached to negative, and lies between it and positive sheet.

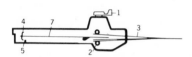

2. Making exposure: Control arm (1) is still at L and rollers (2) are apart. Envelope (3) which is only lightly held by cap (4) is withdrawn along with positive print sheet. Cap (4), held in place by retainer (5), is tightly crimped to negative (7) which stays in holder for exposure.

3. After exposure: Envelope (3) is pushed back into holder; again it is held by cap (4). Control arm (1) is moved to P. This brings rollers (2) together and presses them tightly against film packet (3). Moving arm to P also retracts retainer (5 in drawings above) so cap (4) and negative attached to it are withdrawn with rest of film packet.

4. To develop: With control arm (1) at P, packet is drawn through steel rollers (2) which crush pod and spread developer (6) evenly between positive and negative. This starts development of picture.

The Polaroid 4 X 5 Land camera system is used in commercial studios with a 4 X 5 camera, either for original photographs or to check exposure, lighting, framing, and angles. The system can be used with the Polaroid MP-4 Multi-purpose Land camera for photomicrography, macrophotography, closeup and reduction photography, and all types of copy.

The film holder is built to withstand strenuous professional use without damage. All operating mechanisms are enclosed.

Films for large format Polaroid photography

Polaroid markets five large format films: Type 55 P/N, Type 57, Type 52, Type 58, Type 51.

Polaroid Type 55 P/N 4 X 5 Land film simultaneously produces a completely developed negative and a positive in seconds, outside the darkroom. The acetate base negative has extremely fine grain, high resolvency (better than 150 lines per millimeter), good contrast, and maximum density. Englargements can be made up to 25 times original size without objectionable graininess or loss of detail.

Polaroid Polapan Type 52 film is a pancromatic, black and white, general purpose film that provides a finished print in seconds. It produces virtually grainless pictures with excellent detail, and has the widest photographic tonal range of any Polaroid Land film. Prints can be enlarged up to two and one-half times without significant loss of detail.

Polaroid Type 51 high contrast 4 X 5 film produces a picture with saturated blacks and clean whites in just seconds. Its high contrast makes it ideal for line work, production of screened prints, and special effects photography such as tone separations and silhouetting. It is also useful for renditions of contrast detail in photomicrography.

Polaroid Type 57 3000 speed film is the most sensitive black and white pancromatic film offered for general purpose photography. It's ideal for photographing high speed operations and for available light photography. Type 57's sensitivity to ultraviolet light makes it useful in fluorescing applications such as chromatography and metallurgical quality control.

Polacolor Type 58 film produces a finished full color image in 60 seconds. Colors are natural and show good detail even in shadow areas. Tonal variations are subtle; skin tones are especially pleasing.

All five Polaroid 4 X 5 Land films are now made by a new automatic process (previously, because of their complex design, they had to be assembled by hand), so greater quality control is possible. The film packet has been redesigned so it's easier to open than ever before—you simply tear it apart. Peeling the finished print from the negative is cleaner; there's little chance of getting excess developer on your fingers or the finished print. The packet has a new metal clip for smoother operation in the film holder. It is stiffer, so it won't buckle when inserted into the

Polaroid portraits

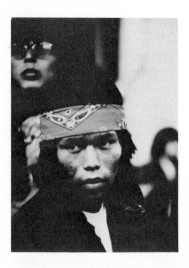

The photographs on these pages give a hint of the versatility of Polaroid photography for the broad spectrum of modern portraiture. The photograph of the American Indian was executed under natural light by Robert Seitz. Noted actor Rod Steiger in the role of Captain Ahab was photographed backstage by the existing light in the dressing room.

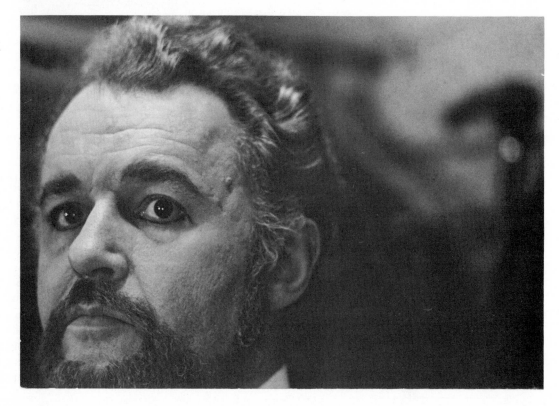

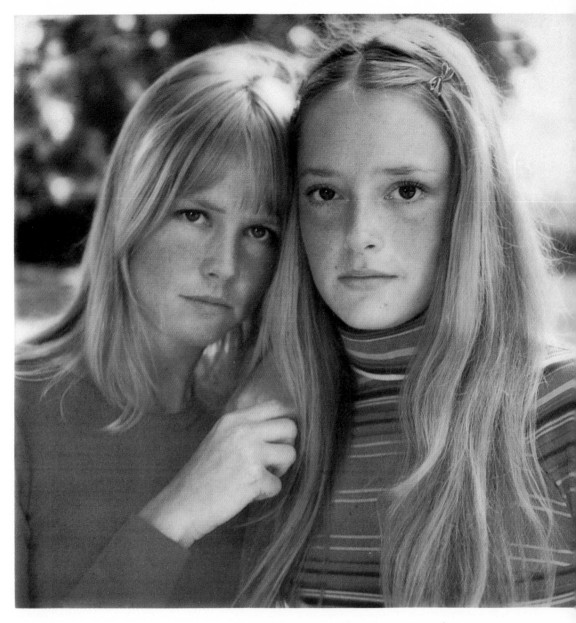

Bill Field, Polaroid's Art Director, produced this gentle and sensitive double portrait with an SX-70 Land camera. Light from the Flashbar brightened colors in the shaded areas. Field has been honored for designing much of the corporation's camera and film packaging and for his many contributions to Polaroid's advertising campaigns.

Inge Reethor

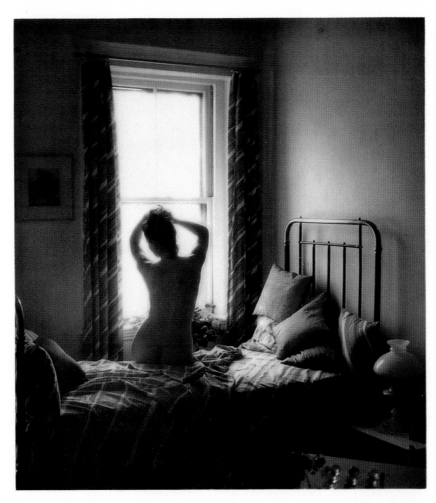

Christian Delbert

The photographs on this and the facing page compliment one another in
many ways. Although made by different photographers, they could
well have been made within yards and moments of each other.
Both exhibit concern and sensitivity for expressive light and subtle color.

IMAGES BY A MASTER OF THE MEDIUM

Inge Reethof is possibly the world's most experienced and expert Polaroid color photographer. A member of the Research and Development Group at Polaroid, she has produced tens of thousands of photographs with the latest films and cameras. Her work is seen in shows, magazines, books, and advertisements.

Miss Reethof's work exhibits a delicate sense of color, a refined awareness of light, and a confident use of space, shapes, and textures. She has an extraordinary talent for finding and producing quality images in astonishing quantities.

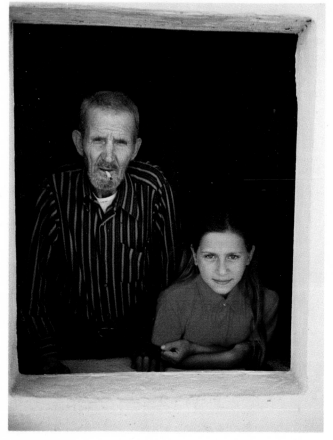

holder. For added convenience, the print format has been changed. The flat edge is perforated; all you have to do is tear it off to get a perfectly trimmed print, or leave it on to record notes. Since the actual film development takes place outside the holder, it is possible to take pictures in rapid succession. The exposed packet may also be removed from the holder for processing at a later time if desired.

FIVE EASY STEPS
TO A FINISHED LARGE-FORMAT PICTURE

1. Insert the film packet into the film holder. (Each packet is a self-contained picture unit—a negative, a positive, and a pod of developing reagent.) As you insert the packet, a spring-loaded catch grasps the metal clip on the packet enabling you to withdraw the protective envelope while the negative remains in the holder.

2. Withdraw the envelope, exposing the negative; take the picture and reinsert the envelope to make a light-tight enclosure.

3. Rotate the processing lever on the holder from the **load** to **process** position. This releases the holding catch and closes stainless steel rollers on either side of the envelope.

4. Pull the entire packet from the holder. The rollers burst the pod, spreading the developing reagent uniformly between the positive and negative.

5. Wait the recommended development time, then tear open the envelope and separate the finished print from the negative.

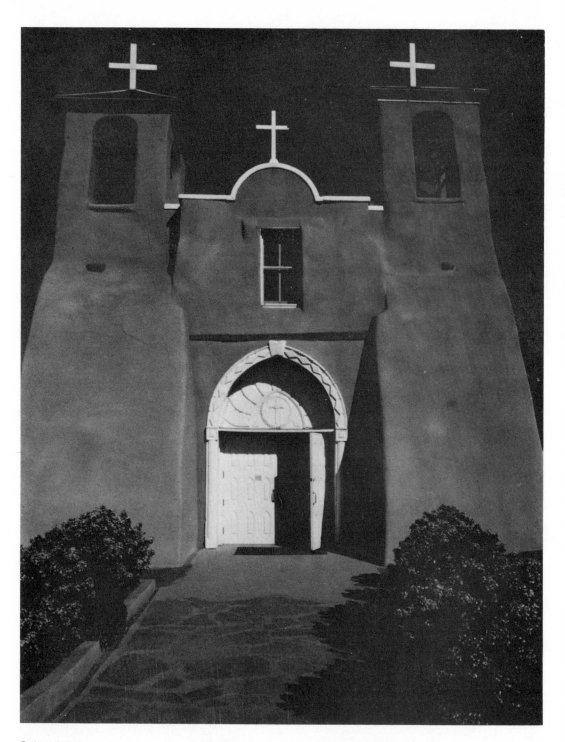

Robert Seitz

8 POLAROID PORTFOLIO

Lynne A. Bentley-Kemp

The high-contrast world of Weston Andrews

These graphic images were produced with the aid of Polaroid Type 51 high contrast 4 X 5 film by Weston Andrews. Many of his images are the result of precisely and selectively compressing the tones of the original subject. This high contrast film allows Andrews to separate a group of lighter or darker tones for special visual effects. Through experimentation, Andrews can reverse and combine images at will. Images such as these lend themselves to reproduction as posters and attention-getting advertisements. Weston Andrew's images are often to be enjoyed for their own special graphic qualities. Type 51 high contrast film can be used in most 4 X 5 cameras and in the MP-4 Industrial View Camera produced by Polaroid.

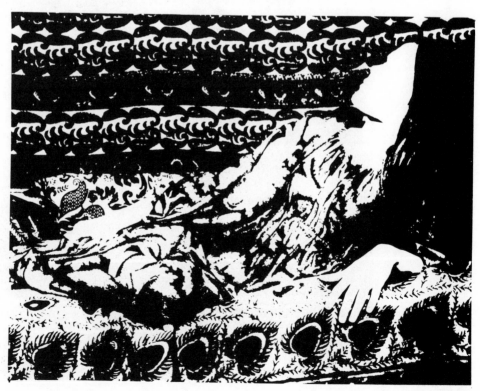

Polaroid portfolio

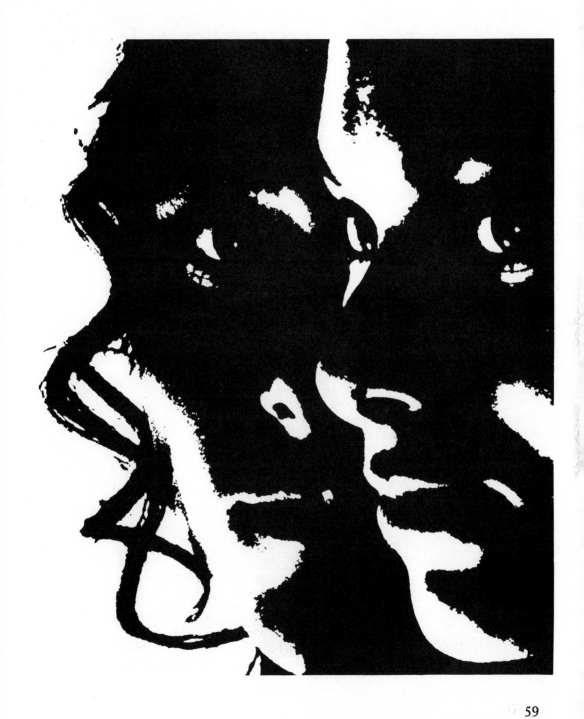

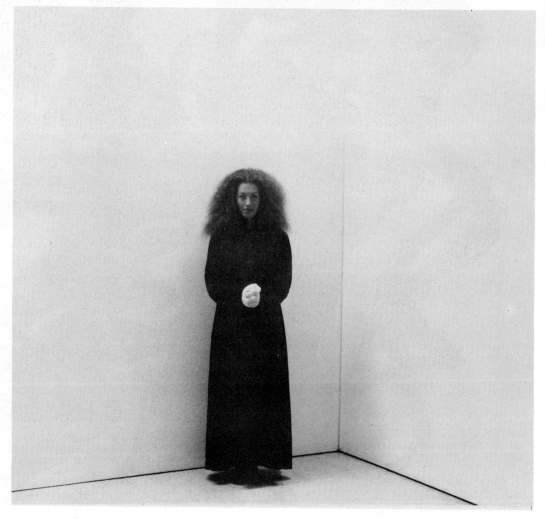

These images are representative of the work of Steven Zoref, a
recent graduate of the College of Graphic Arts and Photography
at the Rochester Institute of Technology.

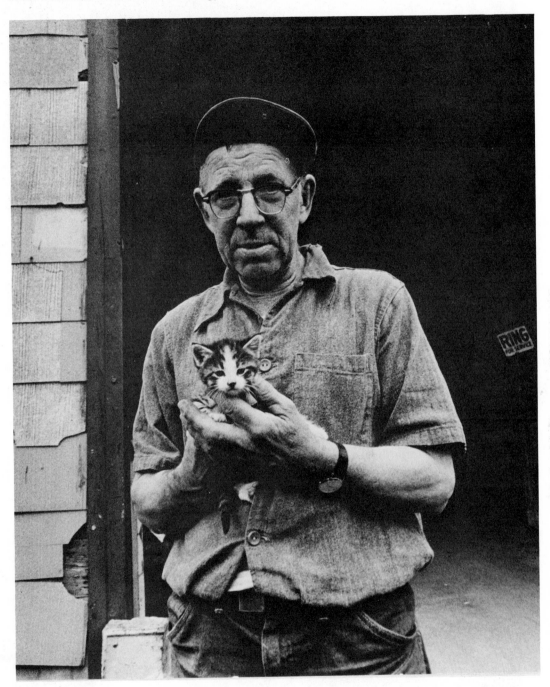

This group of photographs from the author's files are a suggestion of the wide range of subject matter which lends itself to Polaroid photography. The photograph of frost was recorded on Type 52 film in a Crown Graphic camera. The southern coast of France was the setting for the image of waves and a beach walker. The World's Sport Parachuting Championships in Orange, Massachusetts provided the opportunity to photograph with Type 55 P/N film which yields a black and white print and an ultra-finegrain negative. The architect Le Corbusier's dramatic concrete church in Ronchamp, France was photographed on high speed film with a deep red filter.

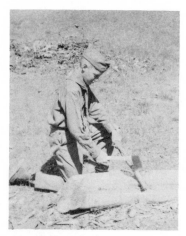

POLAROID PICTURES
TO SPICE UP SCOUTING ACTIVITIES

If you're involved in Boy or Girl Scouting programs, you'll quickly find a multitude of opportunities to use your Polaroid camera. As a teaching aid, "how-to-do-it" photos can clearly show a variety of procedures or techniques. Important exhibits can be preserved in pictures for future reference. Instant pictures are a natural for documenting community projects; everyone will want to get in on the act. Fund raising campaigns can be strengthened with pictures that show the aims and accomplishments of your scouting programs. Polaroid prints can liven up a troop scrapbook with views of jamborees, camping trips, and other highlights of the scouting experience.

POLAROID PICTURES CAN ENRICH
ATHLETIC ACTIVITIES

You can probably think of many ways in which to use a Polaroid camera in your favorite athletic activity. A diver's form, a batter's swing, a bowler's approach, and a runner's start can be photographed and instantly analyzed and studied. And the most critical viewer will be the athlete pictured.

A sequence of pictures of a golfer's drive can easily be made. A Polaroid print can provide graphic assistance to a tennis player working to improve his backhand.

To make effective sports analysis photos, select a location in good light for maximum action stopping in the photo. Select the camera position with the least distracting background. It's a good idea to try a couple of "dry runs" of the action to perfect the timing of the shutter release. Use flash to picture indoor action.

POLAROID PHOTOS
TO SUBSTANTIATE CONSUMER COMPLAINTS

When an appliance stops working soon after purchase or some other item turns out to be defective after only a little use, you can write to the manufacturer and explain the problem. Your explanation will be much more effective if it's documented with revealing photographs. For example, make a close up view of the defective mechanism and send the print with your complaint letter to the manufacturer. Most manufacturers are impressed with visually documented complaints (pictures may aid engineers in solving the problem on the production line) and they often do more than expected to correct the defect. A well documented complaint may result in surprisingly prompt satisfaction.

9 PICTURE TIPS AND IDEAS

POLAROID PICTURES; INSTANT "EYE WITNESS" AT AUTO ACCIDENTS

Over twenty-two million auto accidents are recorded in the United States each year. It's a good idea to carry a camera in your car at all times to photograph any damage from an accident. Pictures taken at the scene are especially valuable because they give an indication of the conditions under which the accident occurred.

For documentation of an accident, take the following pictures:

- Overall view showing cars involved
- A view showing license plates of cars
- Individual views of each car
- Close ups of damage to each car
- Views to show contact points between cars
- Views showing any witnesses
- Any skidmarks from cars involved
- If not evident in above pictures, a view showing weather conditions
- Pictures of driver and passenger of other car (these views can serve to document extent of injuries, if any)
- Pictures document injuries to yourself and passengers, if any.

Careful photo documentation may inhibit opponents from pressing meritless claims. The few dollars invested in photographs may save you from excessive legal defense costs.

A photo inventory of your home

A photo inventory can help you remember what you have in your home and help you substantiate your insurance claim if disaster strikes. Most people find it very difficult to list all the things they have when a home is destroyed by fire. And a fire breaks out in a home in America every forty seconds. Having adequate insurance is not enough; insurance companies will only pay you for the items you can document after the damage has been done, and it's no easy task to remember and prove what possessions you had in a house completely destroyed by fire or ransacked by thieves. A photo inventory can substantiate your claim.

The Insurance Information Institute and most insurance companies suggest a room by room photo inventory with an indication of the value of the items on the back of each photograph. Pictures give a graphic description more valuable and useful than any written description.

A comprehensive photo inventory is a perfect rainy day project. Figure on using about four pictures per room. Stock up on film and flash for a thorough picture making session. Color prints make the most accurate inventory because they show more accurately the details, textures, and colors of your belongings.

Remember to make close-up views of cherished and valuable possessions as you make a comprehensive photo inventory of your residence.

TAKING THE PICTURES

• Outdoor views. If you own a home, make photographs of the front, back and each side of the house. Photograph all additional buildings such as a tool shed, children's playhouse, garage and other features such as a swimming pool complex.

• Interior overall views. Start with one wall of a room and make overlapping views to document the contents. Take a closeup picture of very valuable items likely to increase in value; antiques, jewelry, paintings, etc. Move around the room in a clockwise direction and remember to photograph inside closets and other containers.

LABELLING AND PRESERVING YOUR PHOTO INVENTORY

When you've completed the photography, go back through your home and write all pertinent information about the objects in the pictures on the back of the prints. Include the purchase date and price of the item where possible. List quantities and date the print. Take a few minutes to make an estimate of the present value of your property and check to be sure you're carrying enough insurance.

Store your photo inventory and any receipts you may have in your safe deposit box or any other secure container in a safe place away from your home. Periodically update your inventory by photographing new acquisitions and add these prints to your inventory.

A photo inventory is useful for income tax deductions based on losses not covered by insurance. Such losses are tax deductible after the first $100. Pictures can also be valuable evidence in collecting for damage done to you or your property.

Photographing television images

It's easy to build a permanent record of televised news events or your favorite TV shows. Who knows—perhaps your Polaroid pictures of video images may become collectors' items in the future.

The use of slow shutter speeds will force you to anticipate peaks of action and release the shutter only during those moments when the screen displays a minimum of subject motion. For example, wait until a performer gestures for emphasis or an athlete reaches the apex of a high jump. A tripod will be useful to steady both automatic and manual Polaroid cameras. It's necessary to use a shutter of 1/30th second or slower to be sure of getting a photograph with a complete TV screen image.

ADJUSTING YOUR TV SET FOR PHOTOGRAPHY

For the best quality in photographs, adjust the set so that the contrast of the image is slightly lower than normal. Adjust the brightness control so that both highlight and shadow areas show good detail. The shadows should be a dark gray, rather than a strong black. Adjust the controls on a color set for pleasing tint and color intensity. Shooting with Polaroid cameras allows you to make minor set adjustments on the spot.

ROOM LIGHTING

Watch out for reflections on the face of the television tube. To help eliminate reflections, turn off most or all of the room lights. Reducing the light in the room also helps make the area surrounding the TV inage appear black in your photographs. A black area surrounding the TV image is usually more pleasing than a lighter area showing part of the room or the border around the picture tube.

Don't use flash or flood lighting to photograph television images. These light sources are much brighter than the TV image, and your pictures would show a blank television screen.

TAKING PICTURES

For best results, move in to the minimum focusing distance to fill the picture area in your viewfinder. If you're working with a small TV screen, you may want to use a closeup lens to get a larger image in your photographs.

The Polaroid SX-70 camera with through-the-lens viewing shows you exactly what you'll get in closeup pictures. If the viewfinder on your camera is separate from the lens, it may not show you exactly what will be included in the picture. (See your camera manual.) To center the TV screen on your film with a camera of this type, tip or swing the camera slightly in the direction of the finder window.

SHUTTER-SPEED SETTINGS FOR TV IMAGES

Television images are composed of 525 straight horizontal lines called "scanning lines." The TV image is formed by a moving electron beam which scans the picture. It takes 1/30 second to make a complete picture on the screen. Any photograph made with a shutter speed faster than 1/30 second may have a dark band across the image.

AUTOMATIC CAMERAS

Be sure to move in so that the metering system sees only the TV screen light. When an automatic camera is too far away, the light sensing mechanism "sees" too much of the dark area around the set causing your pictures to be too light. If, while you're photographing TV images, the low-light warning signal appears, it's usually safe to ignore it. You'll have a good chance of getting a satisfactory picture. If the print is a bit dark, adjust the lighten-darken control for a lighter print.

ADJUSTABLE CAMERAS

If you have an adjustable camera with a built-in exposure meter, when you make the meter reading be sure the TV screen fills the picture area as recommended for automatic cameras. If your

camera doesn't have a built-in meter, you can use a separate reflected-light exposure meter to determine the exposure. Hold the meter close to the TV screen so that it reads only the screen. Position your meter to read approximately equal parts of light and dark areas of the TV picture. If no exposure meter is available, make a test exposure. Try 1/15 second at f:8 with Polacolor and 1/30 second at f:16. Since individual adjustments of TV pictures vary, and because improvements are continually being made in color picture tube technology, the suggested exposures are approximate.

SIMPLE CAMERAS

You can photograph television images with most simple cameras when you use Polaroid's 3000 speed film. Your first test print will display any obvious limitations; if the print is far too dark, you'll know the fixed shutter and aperture settings prohibit satisfactory TV image photographs.

COPYRIGHT CONSIDERATIONS

Many television programs are copyrighted. The author and publisher undertake no responsibility concerning any copyright matters which may be involved in photographing television images. Responsibility for complying with the copyright requirements must remain with the person taking the photograph.

10 HOW TO AVOID PICTURE PROBLEMS

If your pictures are not sharp...

Everything fuzzy because bellows were not extended or camera moved.

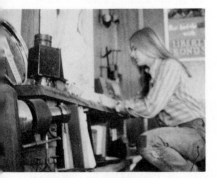

Subject fuzzy because focus was inaccurate or subject moved.

CAUSE:

• the camera or subject moved while the shutter was open, or
• the focus was inaccurate, or
• the camera front was not extended far enough to lock into place.

Other possible causes of fuzzy pictures are

• dirt or a smudge on the camera lens, and
• the camera was too close to the subject without the benefit of a closeup or portrait lens.

REMEDY:

Hold the camera steady since camera motion will spoil picture sharpness. Press the No. 2 red shutter button slowly. If you punch it, the camera will move.

In a dim light, especially with color film, and when making time exposures, the shutter operates slowly. To prevent camera motion, support the camera on a table, bench, or tripod, or steady your arm against a tree or wall. Be sure to hold down the shutter button until you hear a second click which tells you that the shutter has closed.

Try to avoid moving subjects when making color pictures, especially on the "Bright Sun Only" setting on some automatic camera models. At this setting, the shutter operates quite slowly, and any slight camera or subject movement will make your pictures fuzzy.

The lens was smudged by a fingerprint.

With 3000 speed black and white film the shutter is fast enough to "stop" action such as people dancing or children playing. The best shots of nearby subjects are made when the action is coming toward the camera or away from it, rather than back and forth across the camera lens. If a fast moving subject is traveling across the scene, it may be blurred.

Focus the camera accurately. Hold the camera horizontal, aim at the most important subject in the scene, and push the No. 1 buttons all the way to the left. As you look through the viewfinder, push the No. 1 button back toward the right to focus.

On most Color Pack camera models, the subject is in focus when the two images in the viewfinder's bright spot become one clear subject. Try to focus on portions of the subject which contrast, such as a stripe in a necktie, a necklace, or eyeglasses. After you have the subject focused, don't change the camera-to-subject distance, and don't accidentally move the No. 1 buttons while you prepare to snap the picture.

For subjects closer to the camera than 3½ feet, you must use an accessory or closeup lens. These lenses are available in kits from Polaroid for some Color Pack camera models. Check you instruction book for information.

Be sure the camera lens is clean. A smudge, fingerprint, or condensation on the lens will give a fuzzy picture every time. Check the lens before each picture. If it's dirty, clean it with some dry cotton or tissue. Never use silicone eyeglass tissue.

If you had trouble like this...

CAUSE:

· Picture was not developed long enough.

· An underdeveloped black and white picture is flat, gray, and muddy-looking, with no rich blacks. It may also be mottled or blotchy.

REMEDY:

· When using pack film, start timing development immediately after pulling the yellow tab completely out of the camera.

· When using roll film, start timing development after pulling the tab.

· The minimum development time for black and white pictures at 70°F is 15 seconds. When in doubt, it is better to overdevelop than underdevelop. As the temperature drops, longer development is required as shown below.

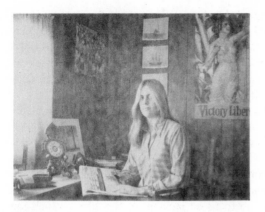

Underdeveloped picture. Development time about 5 seconds.

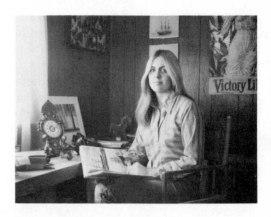

Picture developed for proper length of time.

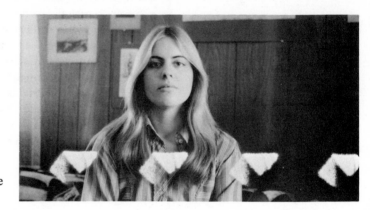

Repeated spots across picture area.

CAUSE:

Dirt or developer chemicals had accumulated on the developer spreader (rollers) in the camera.

PREVENTION:

The developer spreader must be kept clean at all times. Cleaning instructions are in your camera instruction book.

• Before loading a pack of film, you should check the rollers to see if they need to be cleaned.

• If you get a picture that indicates the rollers may be dirty, remember: You can open the back of the camera at any time to clean the rollers. (You should do this away from bright light, and be careful not to move the film pack.)

Flash picture tips

Pick a light colored background and place your subject close to it. Many flash pictures are too dark because the background was very dark or beyond the range of the flash. This is especially true in large areas such as auditoriums, churches, large banquet halls, etc., and even in your living room, if the subject is not close to a wall or other surface.

Move in close to your subject. Another common picture-taking error is to stand too far away. Don't try to get too much into one picture. Be selective. For pleasing pictures of people, make the people important. And remember, the light from your camera's flash can only travel so far (see "Flash ranges" below).

Flash ranges:
Cameras with Focused Flash:−−3½ to 10 ft.
Other Colorpack cameras:−−3½ to 8 ft.

Choose a light colored background and place your subject near it.

When taking pictures of groups, arrange your subjects so they are all about the same distance from the camera. If some subjects are much closer than others, the exposure will be uneven: some subjects may be too light, others too dark. Be a director. Ask your subjects to move this way or that; it's well worth the effort.

Avoid backgrounds with glass, metal, or other reflective surfaces. Light from the flash will reflect back into the camera lens, and an unpleasant "hot spot" will spoil the picture. If you can't take the picture somewhere else, shoot at an angle.

Move in close for good people pictures.

Arrange groups so right amount of light reaches each subject.

Shoot at an angle.

BLURRED PICTURES

Focusing. When using color film, you must set the distance scale on the camera to the actual camera-to-subject distance. (If your camera has Focused Flash, you must do this when using black and white film, too.) Measure or carefully estimate the distance, or use your camera's distance-finding device. If the distance scale is not set correctly, your pictures will not be sharp and, if your camera has Focused Flash, they will also be too light or too dark.

Subjects too far away.

Background too far from subject.

Camera movement. Always hold the camera steady until after the flash has fired. Camera movement can cause blurred pictures.

Remember . . .

You must use flash for all indoor pictures. Indoor color pictures without flash will be fuzzy, too dark, and the colors untrue. Black and white pictures often will be fuzzy and too dark.

Subjects unevenly exposed.

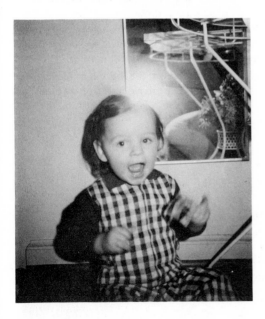

Reflective background.

FLASH PICTURE CHECKLIST

	COLOR	B & W
Camera settings		
• Film Selector	"75"	"3000"
• LIGHTEN-DARKEN control	LIGHTEN Normal DARKEN	LIGHTEN Normal DARKEN
• Distance Scale	4 5 6	4 5 6
Background		
• Light colored		
• Close to subject		
• Not reflective		
• Pleasing		
Camera-subject distance		
• Closest	3½ ft.	3½ ft.
• Farthest	8-10 ft.	8-10 ft.

Miscellaneous

• Fresh bulb facing front.

• Frame subject carefully in viewfinder window.

• Hold camera steady until after flash has fired.

• Pull tabs straight. Time development carefully.

If a yellow tab does not appear
when you pull a white tab . . .

CAUSES:

• Dirt or developer chemicals may have accumulated on the developer spreader inside the camera, or in the yellow tab slot.

• You may have blocked the yellow tab slot with your fingers while pulling the white tab.

PREVENTIONS:

• **Keep the developer spreader clean at all times.** You should inspect it each time you load a pack of film, and clean it if necessary,

• **When pulling the tabs, always hold the camera as shown in your camera instruction book.** Be sure to use the T-handle if your camera has one.

• **DO NOT** pull another white tab. More film will jam up if you do.

• **DO NOT** try to feed the yellow tab through the developer spreader yourself. If you do, the picture will be only partially developed or light-struck, and you may spoil more film.

• **DO NOT** try to pull the yellow tab between the camera door and the camera body (white tab slot). If you do, the film may tear apart, or you will get a picture with marks and streaks.

HERE'S WHAT TO DO
WHEN A YELLOW TAB DOES NOT APPEAR:

• Carefully open the back of the camera enough so you can place a finger or a pencil point on the edge of the film pack inside, as shown above. Then hold the film pack in position while you open the camera back all the way.

• Gently pull any visible yellow tabs out of the film pack, as shown, and discard them. Be careful not to move the film pack.

• Make sure the developer spreader is clean.

• To get ready for picture taking again, unfold the top white tab so that it sticks out of the camera, as shown, then close the camera back. Be sure both sides are latched securely.

If a white tab does not appear . . .

CAUSES:

· The white tabs may have been separated from the safety cover, or from each other.

· The white tabs may have been trapped between the film pack and the camera body during loading.

PREVENTIONS:

Never separate the white tabs from the black safety cover or from each other. They are meant to be joined together, as shown below:

When you load your camera, always check to be sure that the white tabs are not caught between the film pack and the camera body, by raising them slightly with your finger, as shown below:

Here's how to free the white tabs:

• Unlatch and carefully open the back of the camera.

• Without moving the film pack, unfold the top white tab so that it sticks out of the camera, as shown in step 4 above.

• Close the back of the camera. Be sure both sides are latched securely.

SOME OTHER TAB PULLING ERRORS TO AVOID

Never pull a white tab at the same time you pull out the black safety cover. This may cause a yellow tab to come out the wrong slot on the camera.

Always pull the white tabs in order. They are numbered 1 through 8. Never pull the white tab at the bottom of the pile first—it's for picture number 8.

Consumer services at Polaroid

How does Polaroid Corporation treat the many millions of consumers after they have bought the company's products? Polaroid has three departments whose mission is to fulfill the company's obligations to the consumer after he or she has bought one of their products.

The editorial department produces all the instructional material necessary to help the consumer use the product successfully. This includes the books that go with the camera, the sheets in the film boxes, and product information such as symbols, color codes, and other written or visual aids. All the text that appears on the packaging, in short, everything the customer needs to know or know about in order to use the product with satisfaction. For the international markets, this means presenting the information in eight languages.

Customer service answers all requests for information about the product, listens to complaints with a sympathetic ear, advises customers on how to solve picture taking problems, maintains a large assortment of supplementary instructional aids covering all the kinds of film and cameras ever made, occasionally dispenses free film (and sometimes cameras) to owners who have encountered various types of difficulties, provides wide-ranging technological assistance to amateur snapshooters and skilled professionals, and in general is the helping hand and friendly counselor for anyone using Polaroid products. Customer service in the USA receives over 200,000 letters a year and a sincere effort is made to give each one careful, personal attention. Customers anywhere in the USA or Canada can make toll-free calls to customer service in Cambridge if they need information or assistance.

Camera products services repairs the customers' camera if it malfunctions or gets damaged. This division operates camera repair shops in the eight regional service centers, and trains and supervises the technical competence of 17 independent, authorized repair stations.

All the consumer services described are currently in operation in the USA. In international markets they will vary according to the size of the market, particular local problems, and local customs. The general intent is the same—to treat the customer as fairly as possible.

POLAROID'S CAMERA REPAIR SERVICES AND POLICIES

Polaroid Land cameras and accessories are designed and manufactured to give years of trouble-free service. It happens that some cameras develop malfunctions and that others are damaged by the customer. To handle the repair of faulty or damaged equipment, Polaroid has established eight service centers throughout the United States, all of which are fully equipped with specially designed repair tools and test equipment. Repair technicians are fully trained and are retrained on a regular basis.

Cameras and accessories received at Polaroid service centers are repaired and shipped within five working days. Whenever a camera or accessory needs adjustment or is damaged, there are three courses of action that you can follow:

- You can take it to a Polaroid Land camera dealer. He will forward it to the nearest repair facility.
- You can take it to any of Polaroid's repair facilities. While-you-wait service is available for practically every problem at the Polaroid service centers.
- You can mail the camera directly to any Polaroid repair facility. If you can't find an appropriate shipping container, you can call customer service in Cambridge toll-free at 800-225-1384 from anywhere in the USA (except Mass. where you can call collect at 617-864-4568) and Polaroid will send a preaddressed container of the proper size with protective inserts.

The best approach is to call Polaroid, at their expense, and explain the problem before sending the camera in for repair.

POLAROID'S CUSTOMER SERVICE PHILOSOPHY

The customer service department was organized in 1949. For more than 20 years it was headed by the late Mrs. Lois Langly, who had very strong ideas about the way customers should be treated. Many years before it became fashionable to be a consumer advocate, Polaroid Corporation had a large department of them working on the consumer's behalf.

The customer service philosophy includes the following points:

"The purchase of our product includes the right to our help when it is needed. *Caveat emptor* has no place in our business. We are responsible for what we make. Most people who ask for help or make a complaint are genuine and sincere. They are not look-

ing for something for nothing. A satisfied customer is better than an enemy, whatever may be the cause of his annoyance."

To obtain information and help if you ever have a problem with a camera or film or you don't know whether or not a repair is needed, you should seek help promptly to avoid film waste and disappointment. See your dealer or write to the nearest Polaroid office or to Polaroid Corporation, customer service, Cambridge, Mass. 02139, or call customer service toll free at 800-225-1384 from anywhere in the USA except Massachusetts. From within Massachusetts or Canada you may call collect at 617-864-4568. Literature which accompanies the industrial and technical products lists a special collect call number: 617-547-5176. Some users of these products have difficult and complex problems. For questions that this hot line cannot handle, a panel of experts is available within the company. If the question cannot be answered immediately on the phone a return call will be made.

HANDLING THE PROBLEM OF OBSOLESCENCE

There have been many models of Polaroid Land cameras since 1948 when the first model appeared. Since they don't easily wear out some of them are still around, although some are used rarely.

These cameras are obsolete only in the sense that Polaroid has produced and marketed newer models with improved performance and highly desirable features. High grade, black and white film is still available for every roll film model ever made. Even the oldest roll film cameras used with today's roll films can produce pictures of excellent quality.

As customer demand for certain roll film types decreases more and more film dealers decline to stock those film types. As a result, they may be unavailable in many parts of the country. Owners of older model roll film cameras may be caused real hardship by this situation. Customer service at Polaroid provides three forms of assistance for this problem:

• It will supply a customer with the names of dealers in his area who have recently stocked the film he needs.
• It will sell him the film directly from Polaroid's Atlanta distribution center, any desired quantity.
• Or he is offered a very generous trade in allowance towards the purchase of a recent model pack camera.

Polaroid spends millions of dollars for consumer services; they feel it is good business to have satisfied customers.

11 PICTURE PRESENTATION

Your photographs give you an opportunity to relive your most enjoyable moments. Like other items of value, they deserve the best of care. Too often, many of us resort to the "shoebox" technique for storing our valuable prints when with a little effort we could protect them in albums or frames where they would be readily available to enjoy and share with others.

ALBUMS

Photo albums are available from Polaroid or your photo retailer and are an ideal way to store prints. You may want to mount your prints in sequence to tell a story or show how your family has grown through the years.

If the pages of your album do not have clear sleeves to hold the prints in place, use photo corners or cement specially designed for mounting photographs. Kodak Rapid Mounting Cement is moisture-resistant and photographically inert—this means that it will not stain your prints. Also, there is no need to use weights or apply lengthy pressure; just follow the instructions that come with the cement, and press the prints down lightly. Don't mount your prints facing each other on adjoining pages because high humidity could cause the prints to stick together.

Don't use rubber cement or pastes that contain water or penetrating solvents, as these may stain your color prints.

Store your photo albums in an upright position and avoid crowding the albums tightly together. Crowding forces the pages together and could damage your prints.

PROTECTING THE PRINT SURFACE

If you want to display your prints behind glass, be sure that there

is a slight separation between the picture and the glass. This will prevent the emulsion of the print from sticking to the glass under humid conditions. Inserting a mat or shim between the borders of the print and the glass will prevent the print emulsion from sticking to the glass.

MOUNTING ENLARGEMENTS

Mounting can enhance a picture's visual effect because a mount separates a print from its surroundings and emphasizes the picture.

The easiest way to mount enlargements is with a dry mounting tissue.

You can mount your photographs on thin white or colored mounts and then put them into frames, or you can mount them on heavy mounts and trim the mounting boards flush with the prints. With this kind of flush mounting, you don't need to use a frame. You'll find mounting boards in a full range of colors at art supply stores.

FRAMING

Framing your best color prints or enlargements allows you to display your work proudly for others to enjoy with you. You can purchase ready-made frames in standard sizes, have frames made to your specifications, or make your own frames. Remember, if you use glass in the frame, keep a slight separation between the glass and the print surface.

Display your framed (and unframed) photographic prints away from direct sunlight. Prolonged exposure to direct sunlight can cause the dyes in your color prints to change prematurely. Dyes used in color prints, like all other dyes, may change somewhat in time.

ORDERING ADDITIONAL PRINTS

Your prints represent enjoyable memories, and you may want to share some of these memories with others in the form of duplicate prints. Order duplicate prints and enlargements from Polaroid's Copy Service.

Share your photographs with others by keeping them on display in your home and by ordering duplicate prints for those special people in your life.

MAILING

When you mail prints to friends, remember to place a piece of stiff cardboard or similar material behind the print so that it will not be bent or creased easily. Don't use paper clips or staples to hold prints in place, because they will permanently mar the prints. Address the envelope *before* you slip the prints inside because the impression from your writing could mar the surface of a print.

STORAGE AND CARE OF PHOTOGRAPHIC IMAGES

The primary factors affecting the life of photographic images are light, moisture, and heat. For maximum permanence, store prints where it's dark, dry, and cool. Never store your pictures in damp basements or in hot attics. Avoid a relative humidity below 15% because excessive brittleness may result. High relative humidity is dangerous because it increases the possibility of fungus growth. Since the silver image may be attacked by certain sulfur compounds, protect your black and white negatives from any source hydrogen sulfide and coal gas fumes.

Keep prints and negatives as clean and dust-free as possible. A good rule is never to touch the film except by the edges. The best way to protect negatives is to store them in envelopes with side seams. Stores that sell photo products usually offer a variety of containers for storing prints and negatives.

Don't store photographic images near moth-preventive chemicals which could crystallize on the images.